WILLIAM WEGMAN / Fashion Photographs

Texts by William Wegman
and Ingrid Sischy

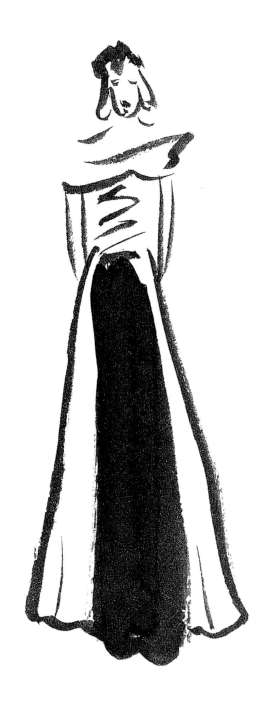

Abradale, New York

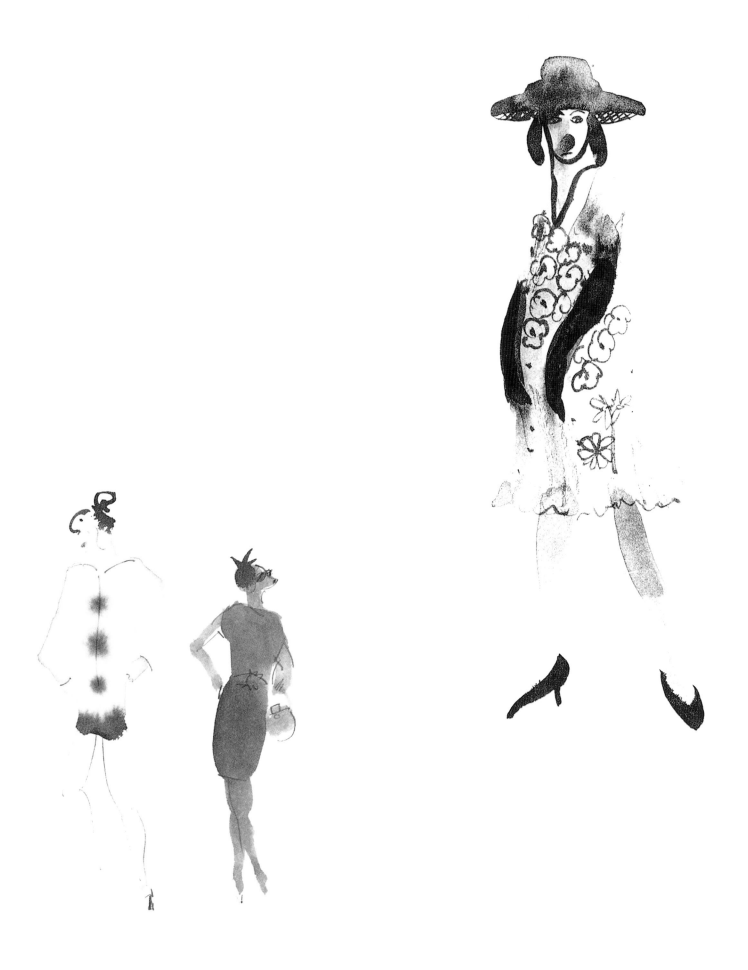

a little background. I didn't always dress up the dogs. My first dog, Man Ray, was spared anthropomorphic adornment. That was left for Fay Ray, my second, a female. Perhaps it was her femininity. We came to a mutual realization that she had a desire to be observed. Anyway, I found myself looking at her for long periods of time. Then one day, after some long looking, I made her tall. I put her upon a pedestal so she would be at my eye level. Before long, I was blurring the pedestal with fabric and creating the illusion of the anthropomorphic vertical. And then on and on. With the birth of Fay's puppies in 1989 came the cast of characters I work with today. Three of the puppies—Chundo, Battina, and Crooky—grew up watching their famous mother model for my photographs, and when it came their turn they were not taken by surprise. They knew what to do.

Before long each dog exhibited a unique personality. When casting my models, I know what to expect. Fay Ray was a woman of power, depth, and hypnotic beauty. In pictures her iron will commands the page. Her daughter, Battina, has a look all her own, casting a sweet insouciant charm on everything in her path. Sexy and girlish even in maturity and motherhood, Batty is very sleepy-eyed and wistful. She appears to daydream, her thoughts far away. Batty's sister Crooky is, by contrast, perky and athletic, spring-loaded, sassy and fresh. Crooky is sportswear. *Seventeen. Self.* Crooky is a little devilish. Batty and Crooky's brother, Chundo, is the ultimate man, masculine and lordly, a gentleman. Vintage *Esquire.* Chundo appears more like the Prince of Wales than the Prince of Wales. He also looks great in uniforms. To his Uncle Chundo, Batty's son Chip is a mere boy, but a devastatingly handsome one. His precious adolescence conveys an uncomplicated look of innocence seldom seen in the pages of today's fashion magazines. Chip is the Hellenic Golden Age, the "David" of dogs. Plato would have found a place for Chip in his Ideal State.

My weimaraners are perfect fashion models. Their elegant slinky forms are covered in gray—and gray, everyone knows, goes with anything.

—William Wegman

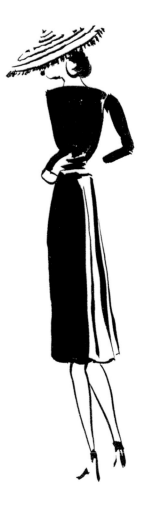

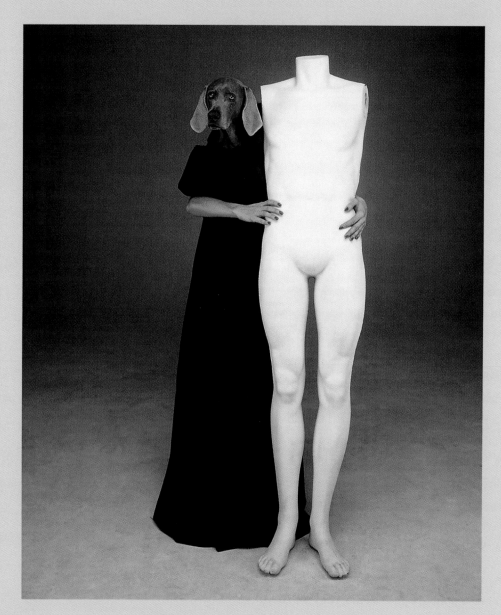

MINDING THE MANNEQUIN, 1999

"I have a very awkward relationship with fashion," Bill Wegman confessed when we were talking about the photographs in this book. He continued, "I'm a little bit timid about it." The fact that he carries over his own feelings about fashion into his work is partly why these fashion photographs, starring Chundo, Battina, Crooky, and Chip, get to us. As well as being about grace and beauty, they're full of moments in which we can sense vulnerability, helping provide plenty of chances for the audience to identify. This is something that doesn't happen in typical fashion photography, but there's much more going on in Wegman's work than just giving people pictures to which they can relate. There is his sharp eye—his strong sense of form, texture, and color, combined with his understanding of content, and narrative. These elements come together and result in opportunities for us to see new things. We also get a chance to work our memories since many of Wegman's images—whether consciously or unconsciously—recall the history of fashion photography. Then, of course, there's the biggest aspect of why these pictures have so much magic—it has to do with the photographer's mind, as well as the relationship that exists between his models and himself.

While we were talking about the photographs, Wegman described a typical day of work in New York when they're all collaborating on pictures at the Polaroid studio in Soho: "The dogs seem to like going to work from beginning to end. They enjoy the walk there, as we cross Washington Square Park and arrive at the studio which is such a familiar place to them. They could make the turn onto Broadway without me. When the door to the studio opens, they explode inside and say 'hi' to everyone. They like their lunch breaks and going out for a walk. Each one has their own way of responding when called upon for pictures. I'll say, 'Batty, you're up,' and she saunters over, while Crooky blasts over, Chundo ambles, and Chip just kind of drags himself. The lights are all set up, with the huge camera in place. It's not as though anybody's sneaking up on them to do pictures. They've watched and been a part of the process since they were puppies.

"The dogs have an obvious pride in what they do. They can sense the feeling in the room, whether the mood is up or down. If it's a great picture they can feel what happens, because everyone stops and goes 'Wow!' They seem to like the process and repetition of it all. They're just not interested in the final pictures."

Some of this sounds similar to what happens between fashion photographers and their human models, while some of it sounds quite different. Wegman says his weimaraners don't need first-class tickets or fancy hotels, but really love a good ride in the car. Although he isn't the first person by far to work with clothes and animals, Wegman makes photographs that are very much a product of his unique vision. Still, he has fun talking the talk. "I'm really discovering legs this year," he told me dryly. What's next? Nudes?

—Ingrid Sischy

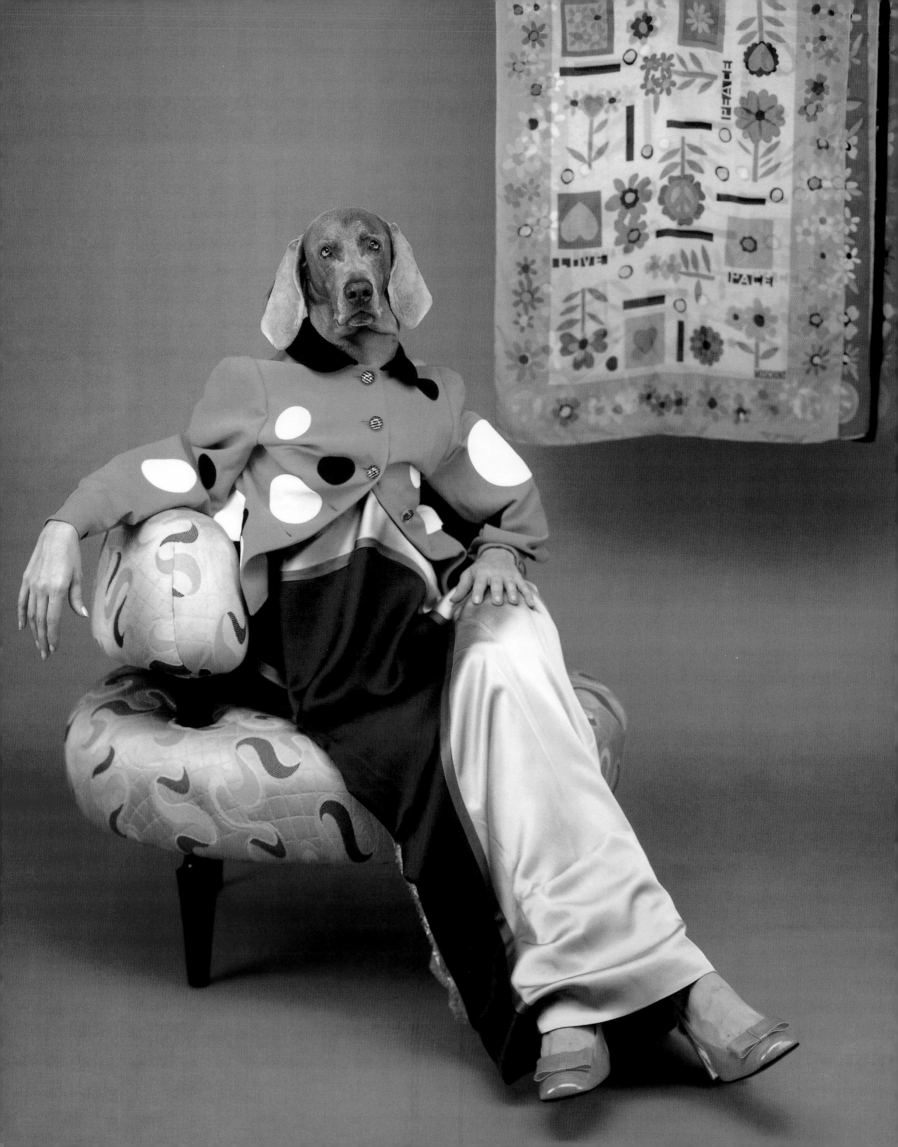

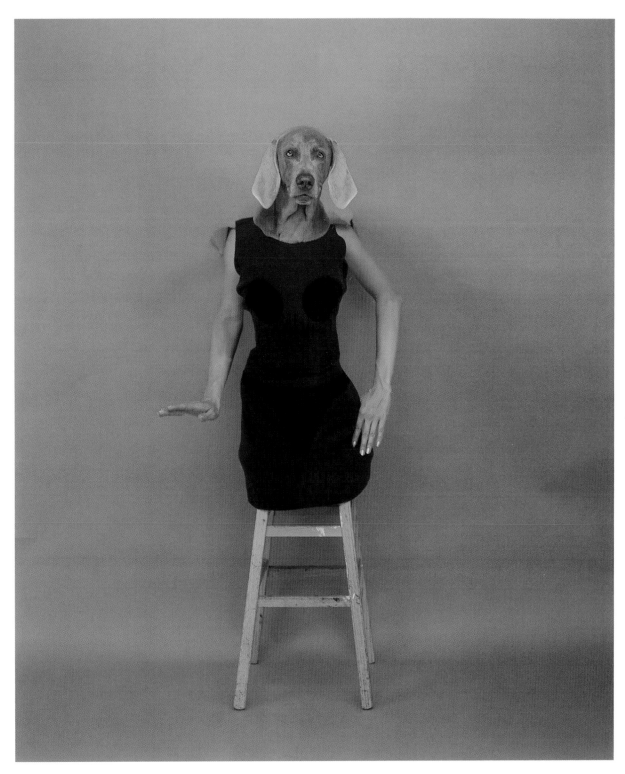

BEACH SCENE, 1996

SITTER, 1996

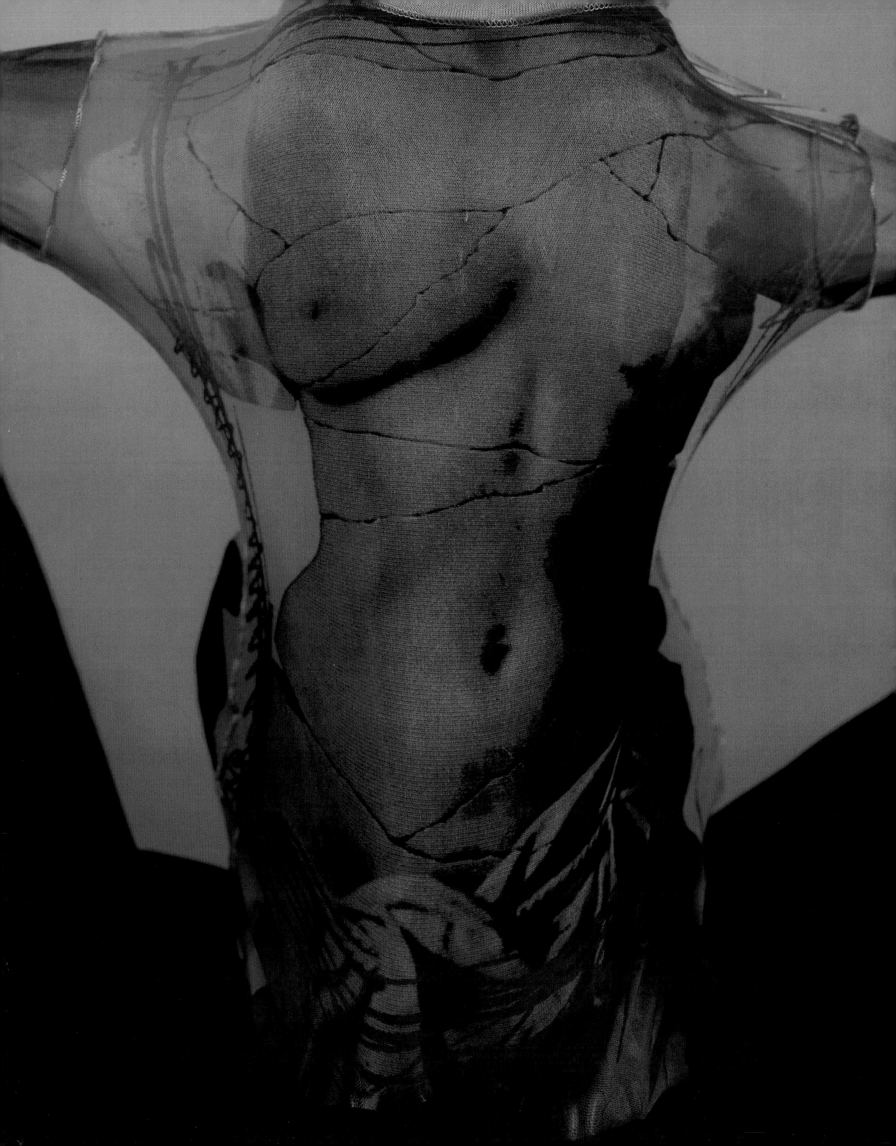

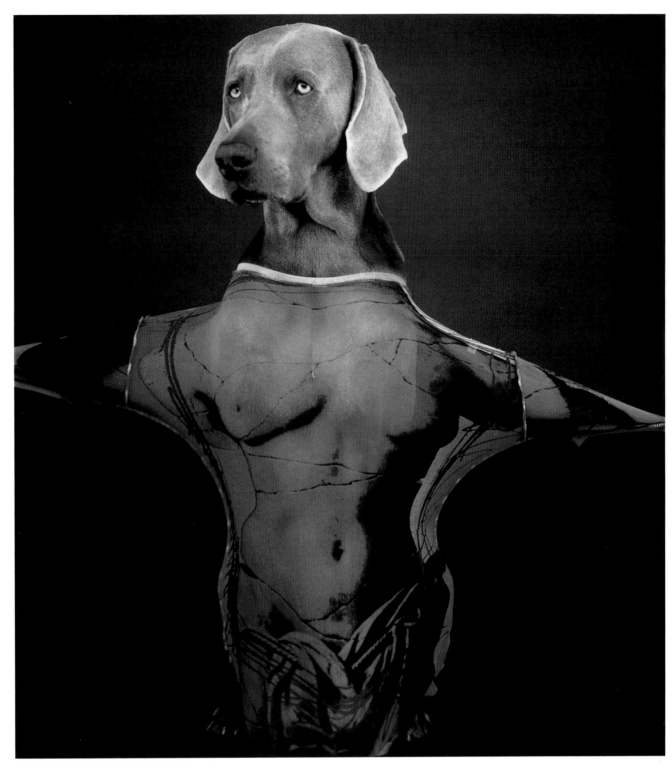

TORSO OR SO, 1999

BODY ART, 1999

RUFFLED GESTURE, 1999

THIS WAY AND THAT, 1996

THE BOUNCING BALL, 1996

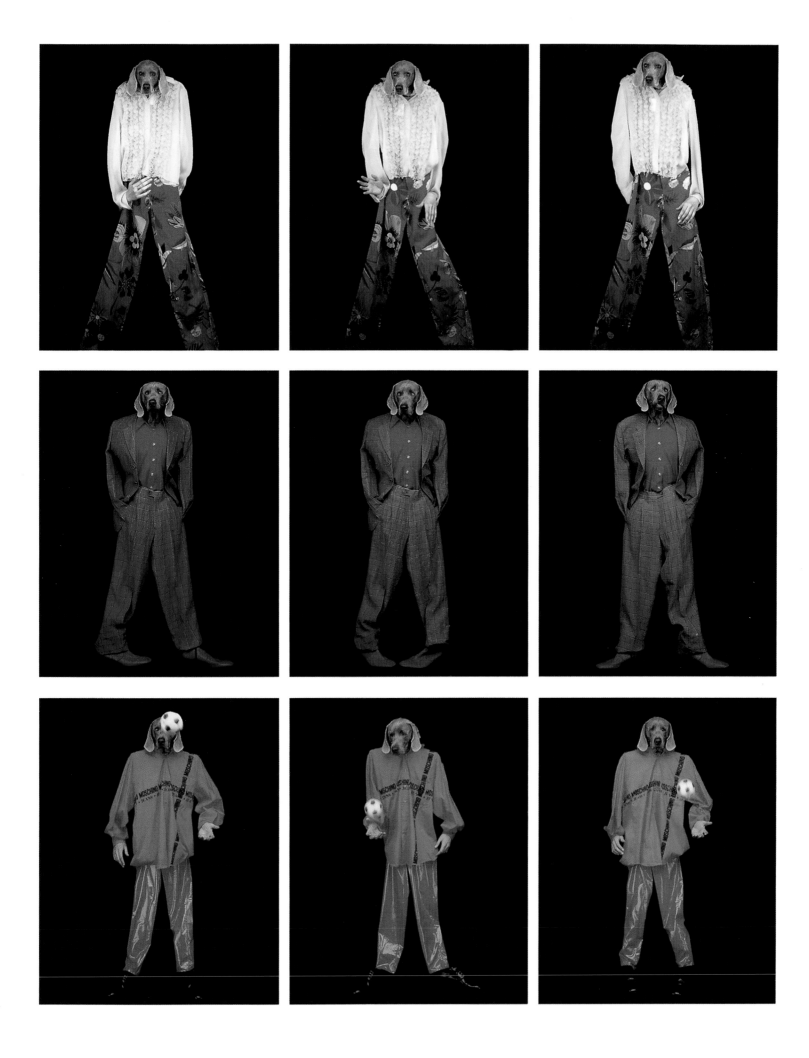

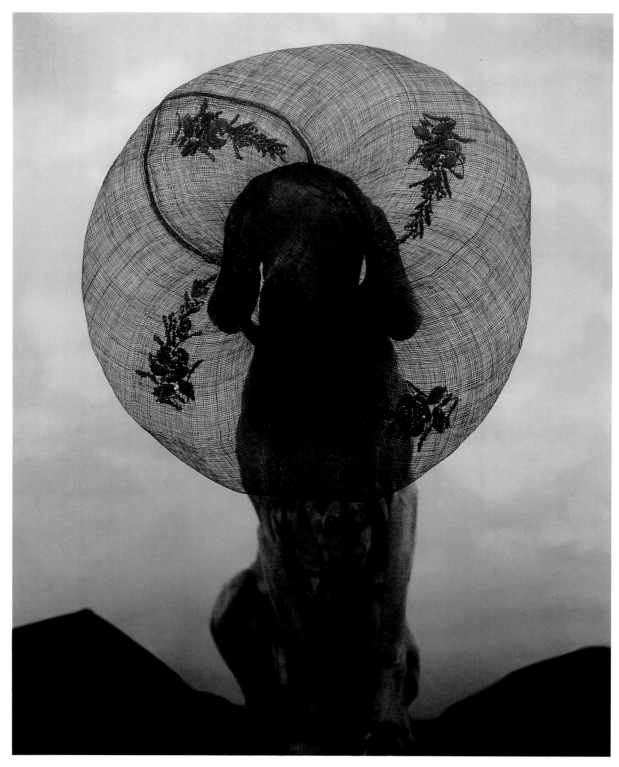

WINDMILL, 1999

MIGRATORY, 1999

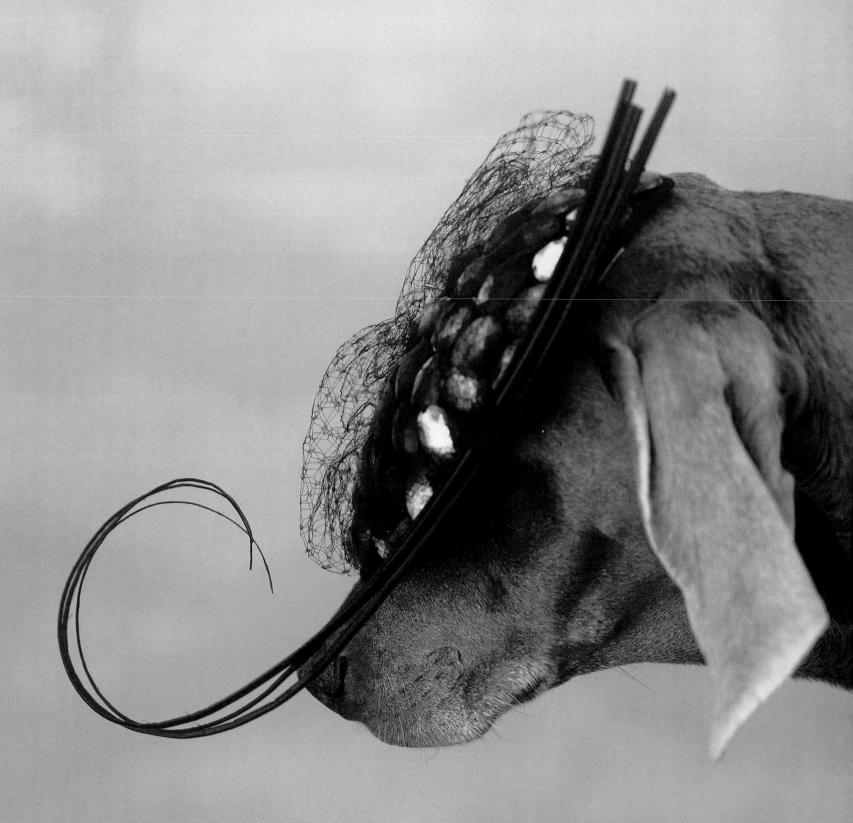

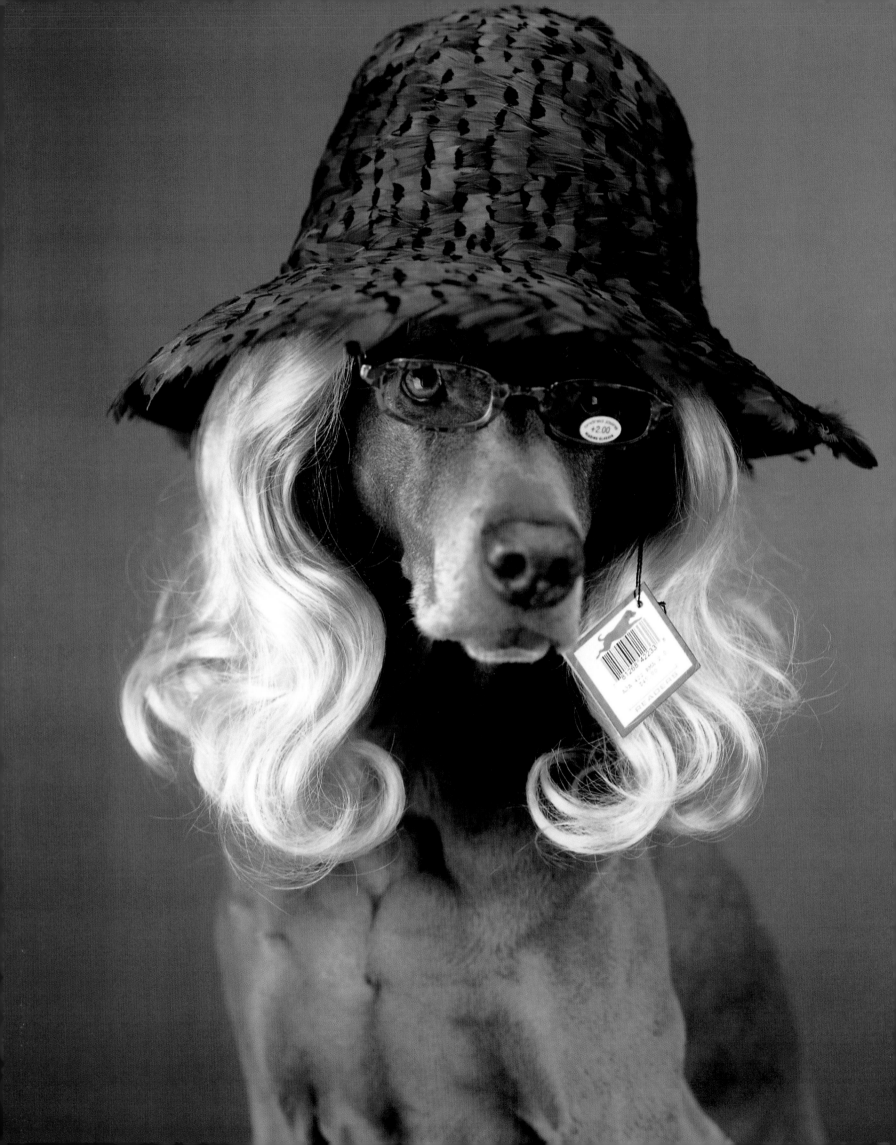

READER, 1999

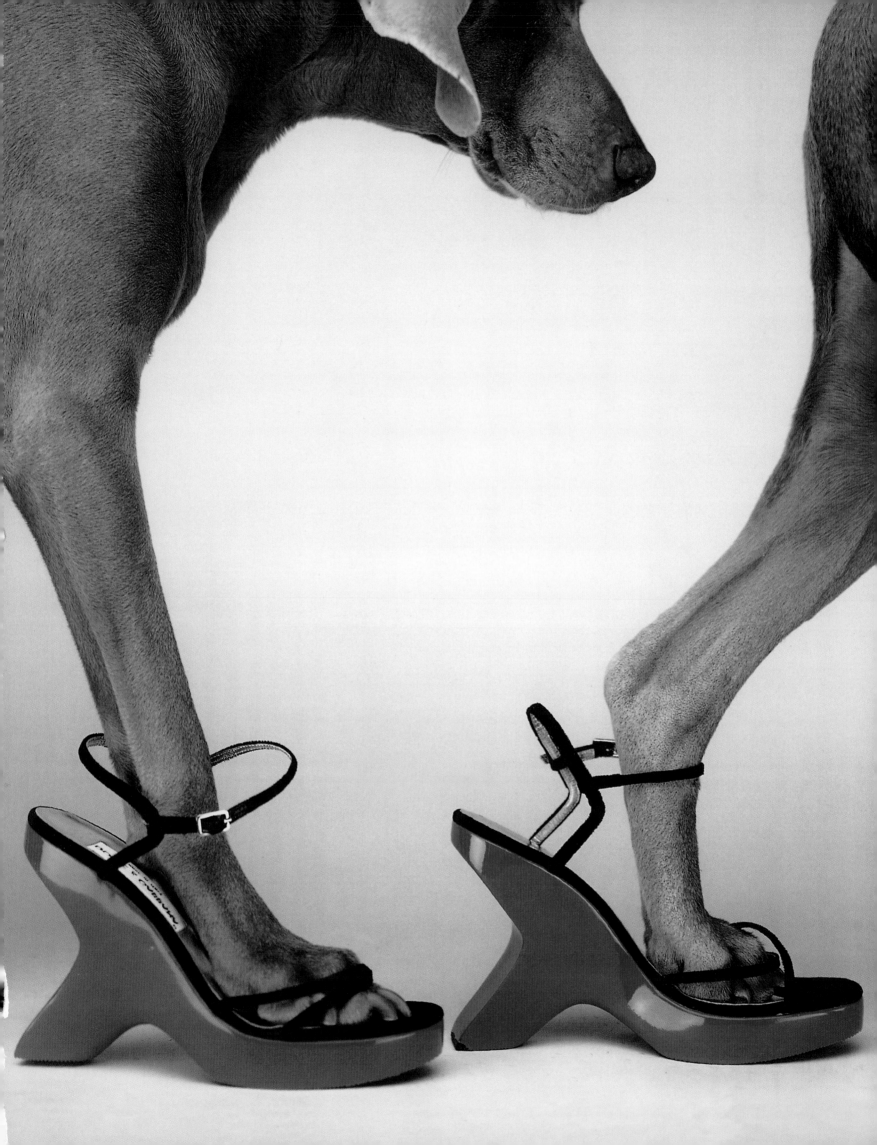

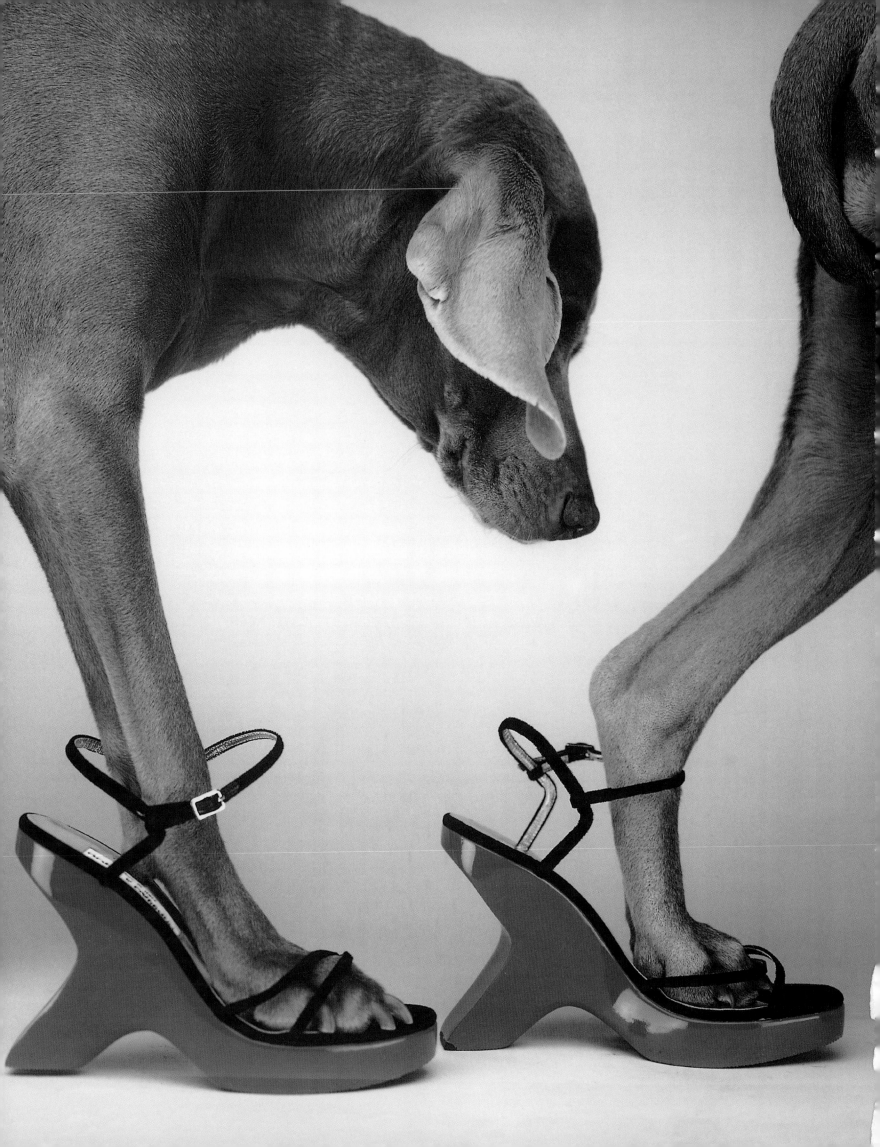

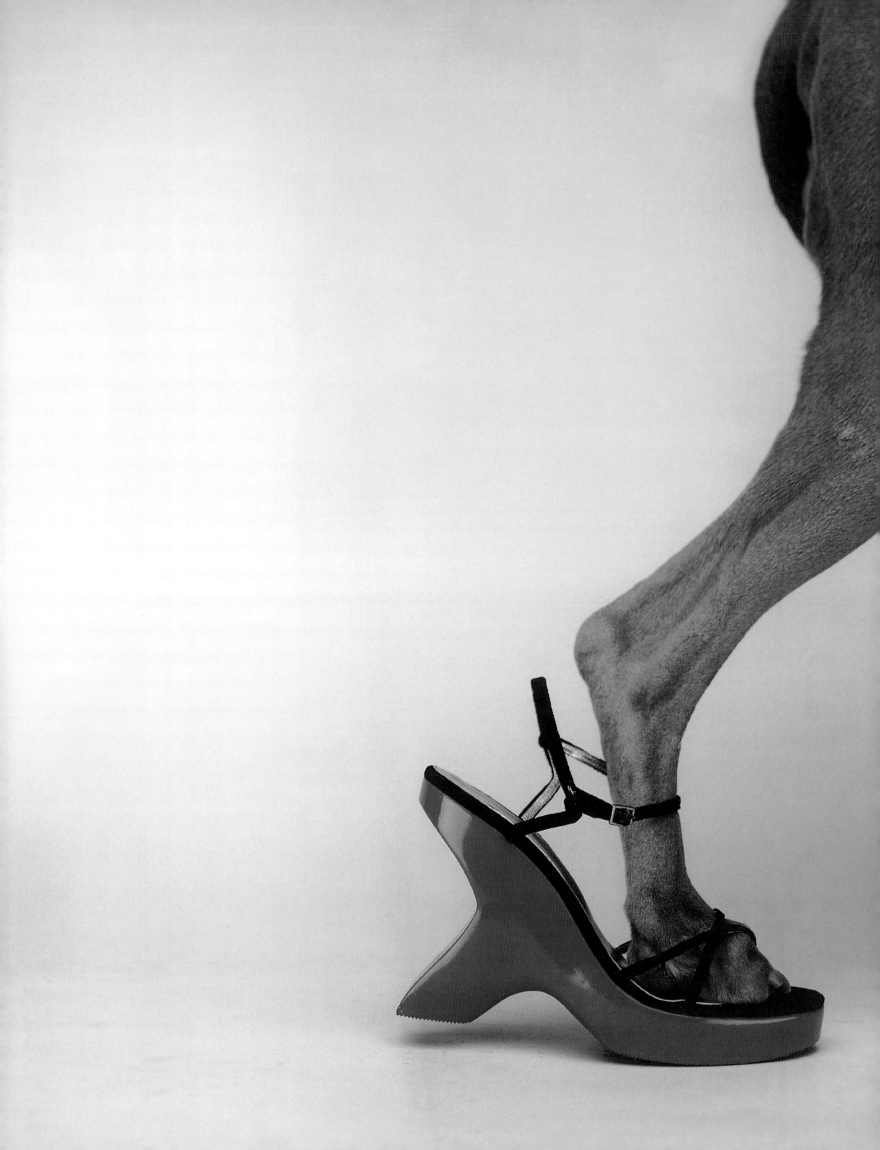

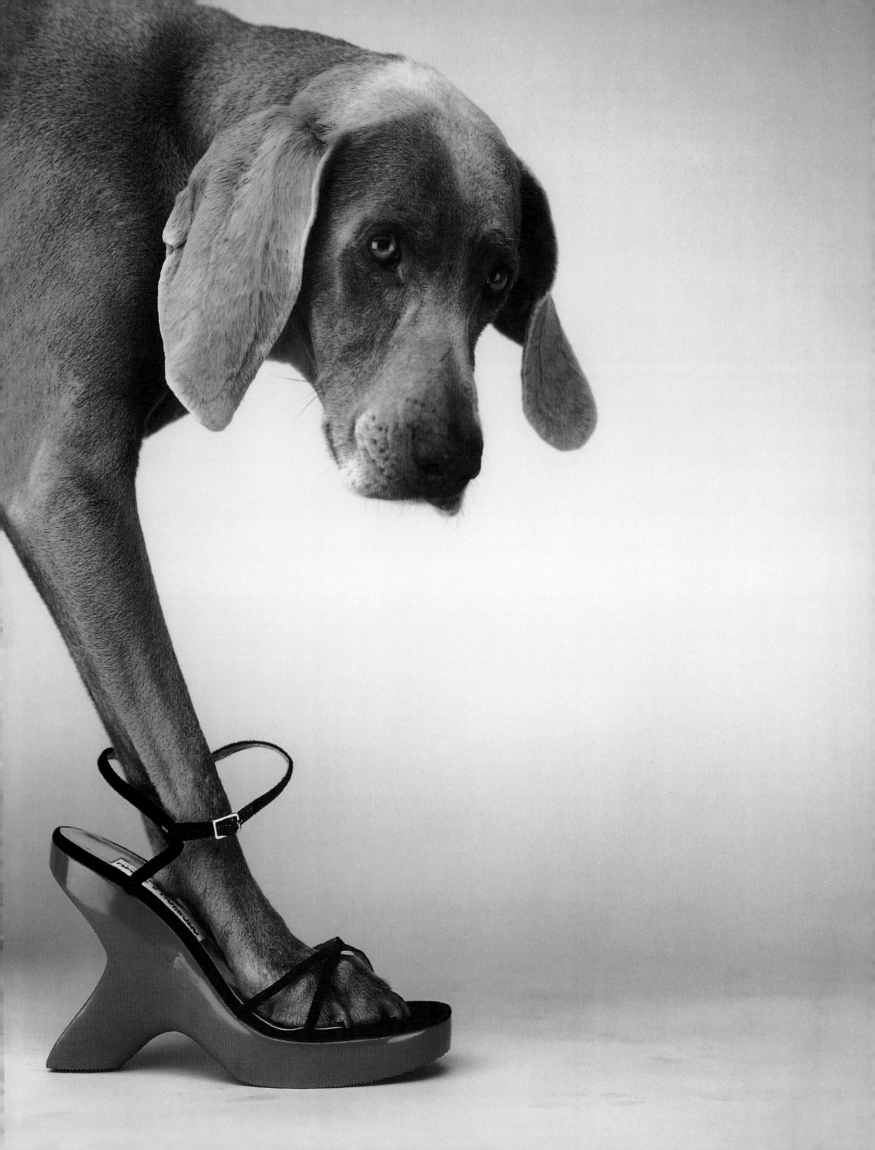

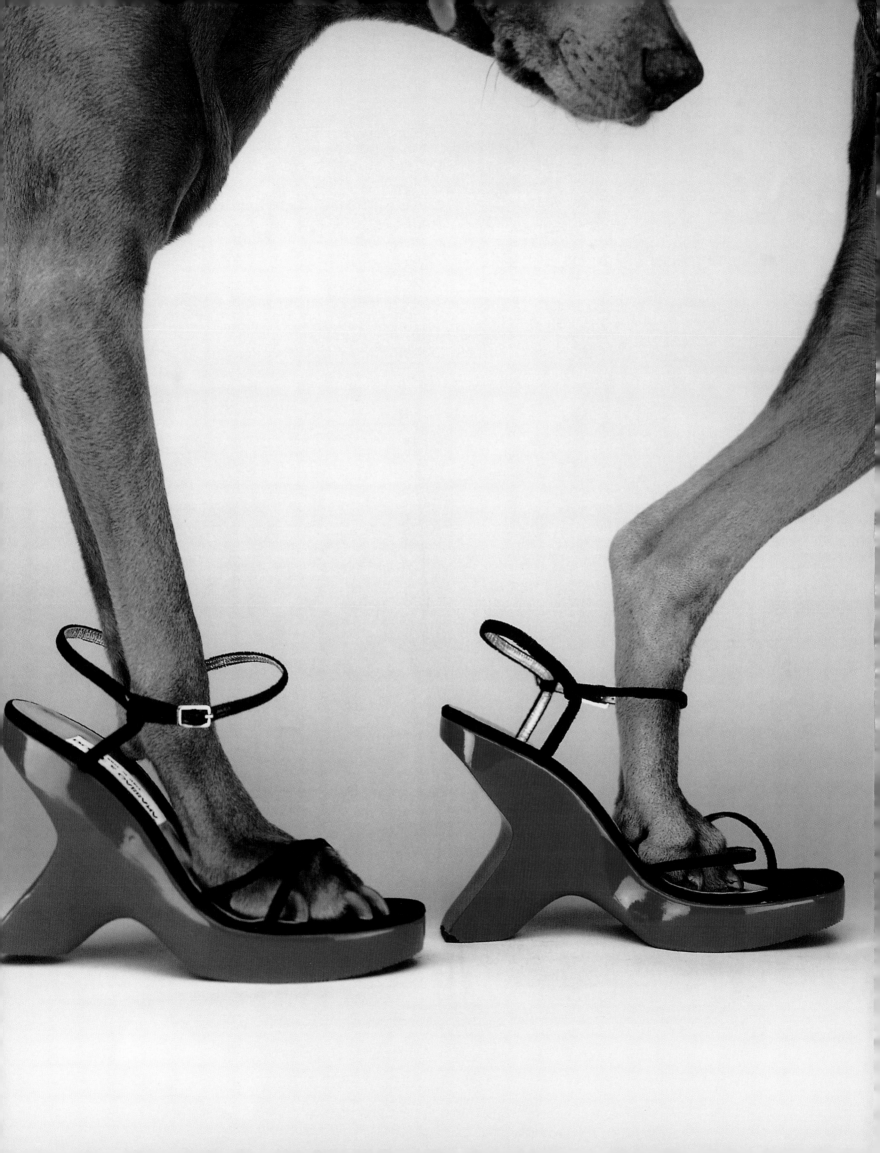

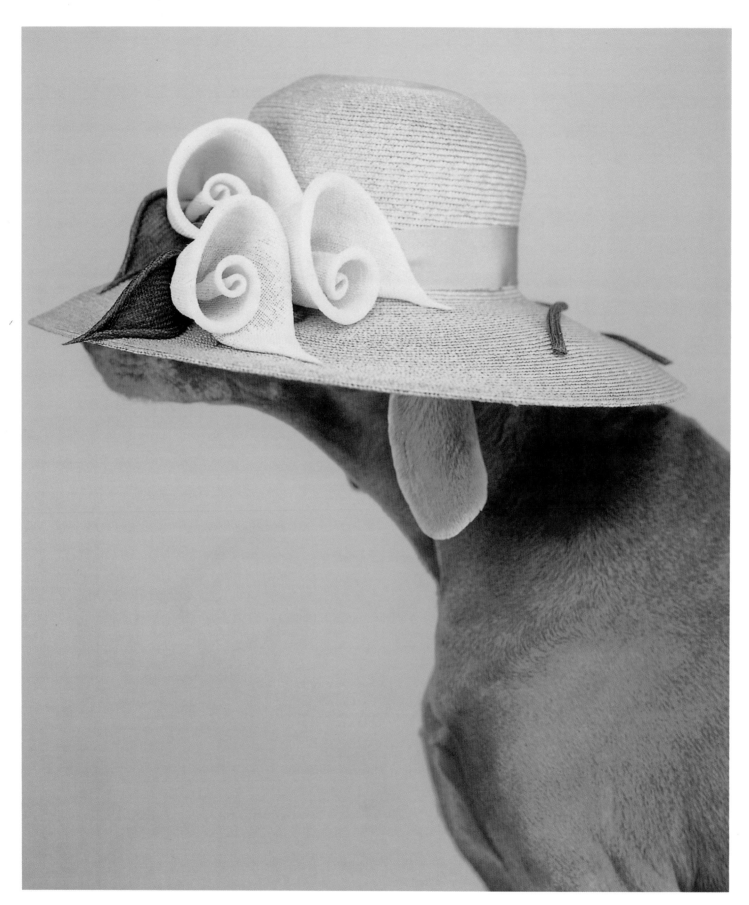

CALLA LILY, 1999

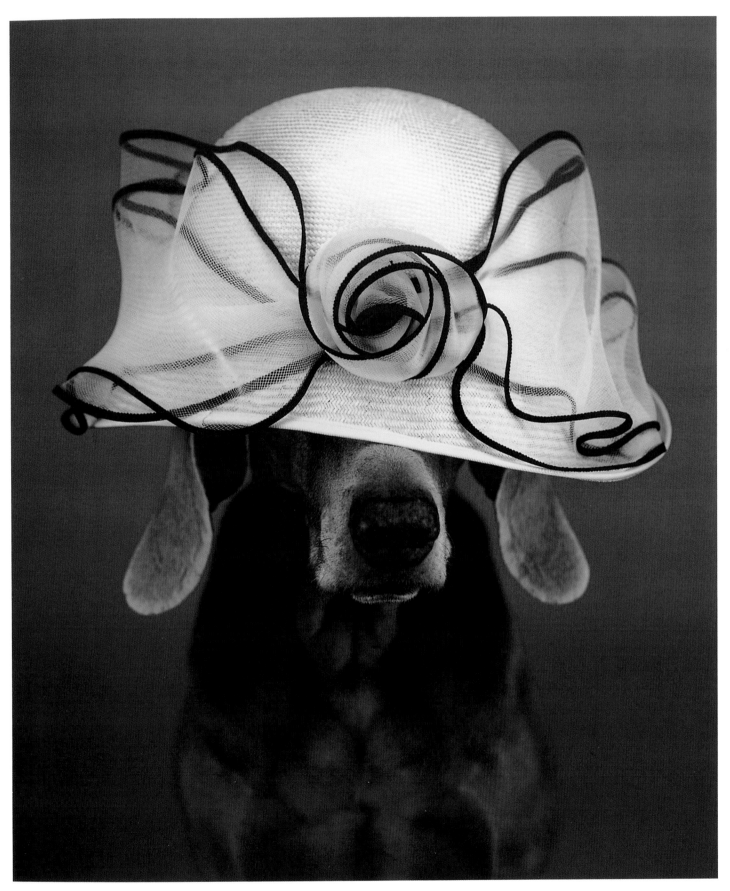

EYE OF THE DOG, 1999

OVERLEAF: HATTER, 1999 (LEFT). BEN DAY, 1999 (RIGHT)

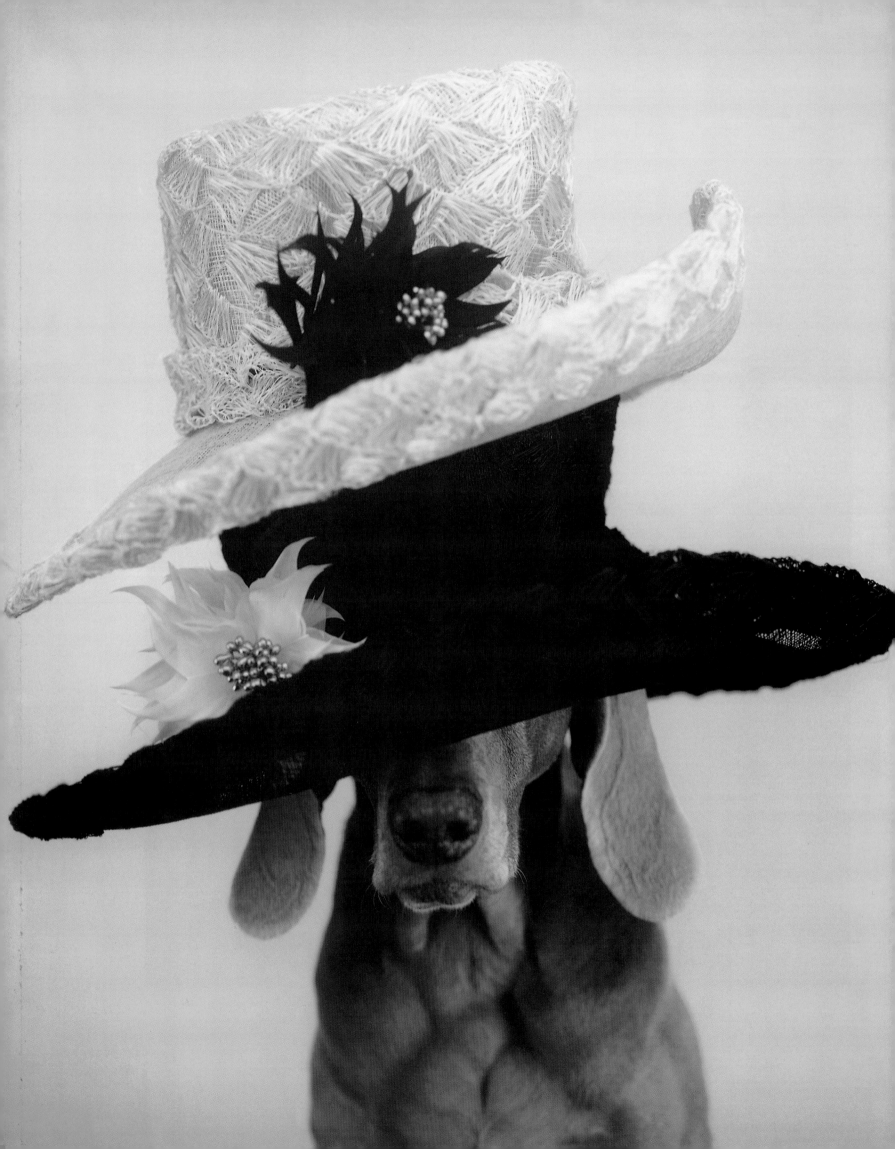

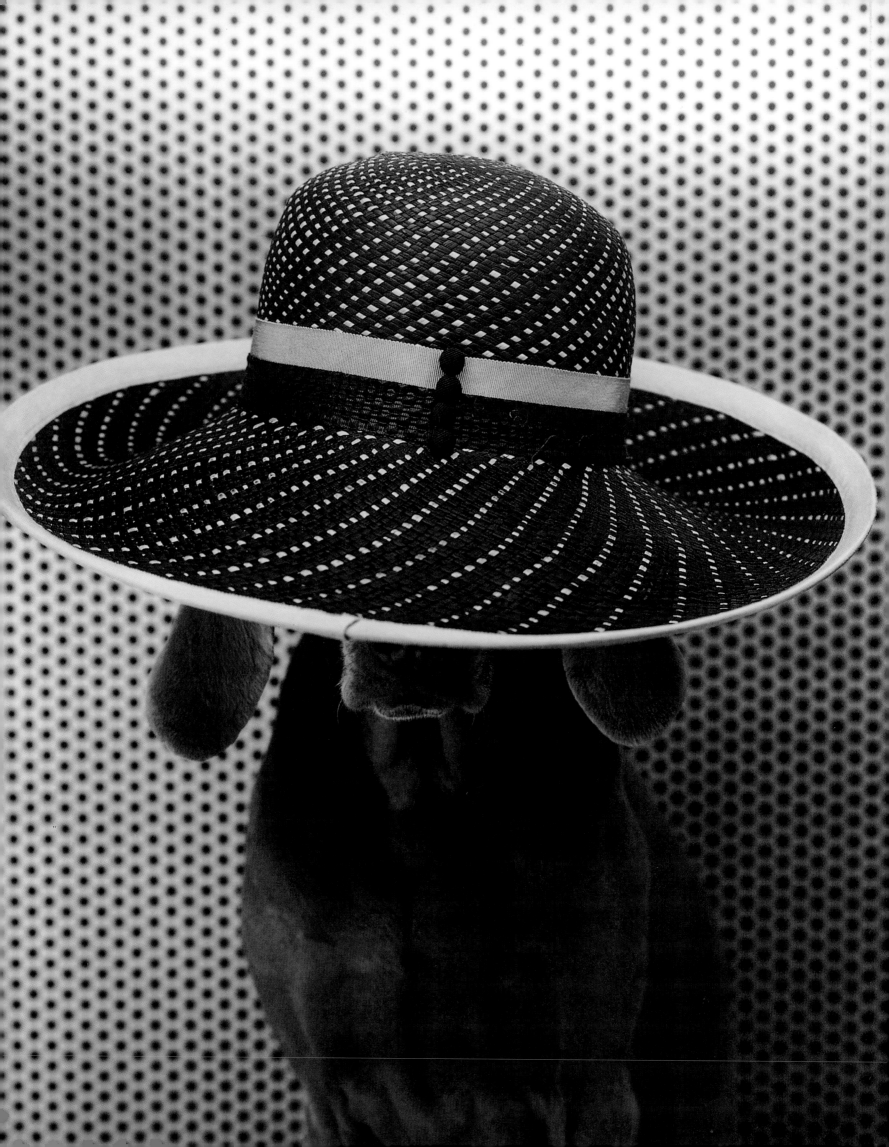

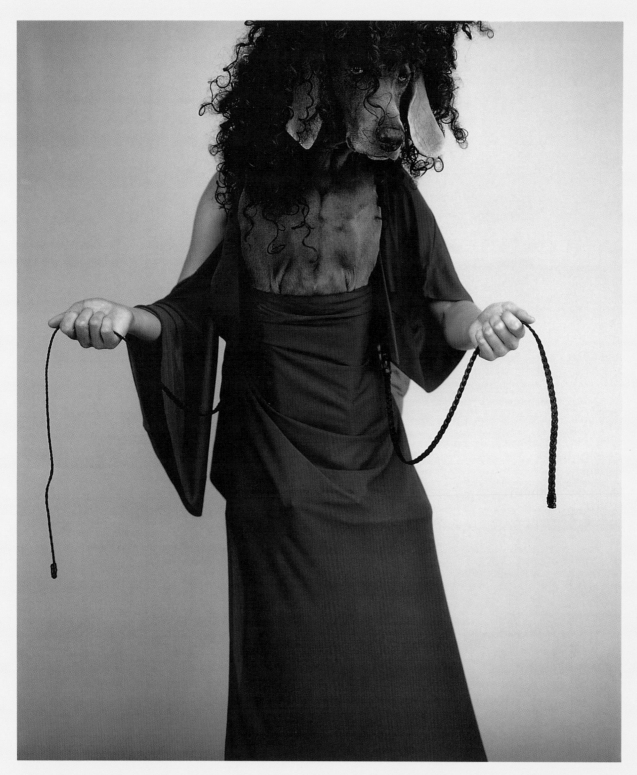

TRAINER, 1999

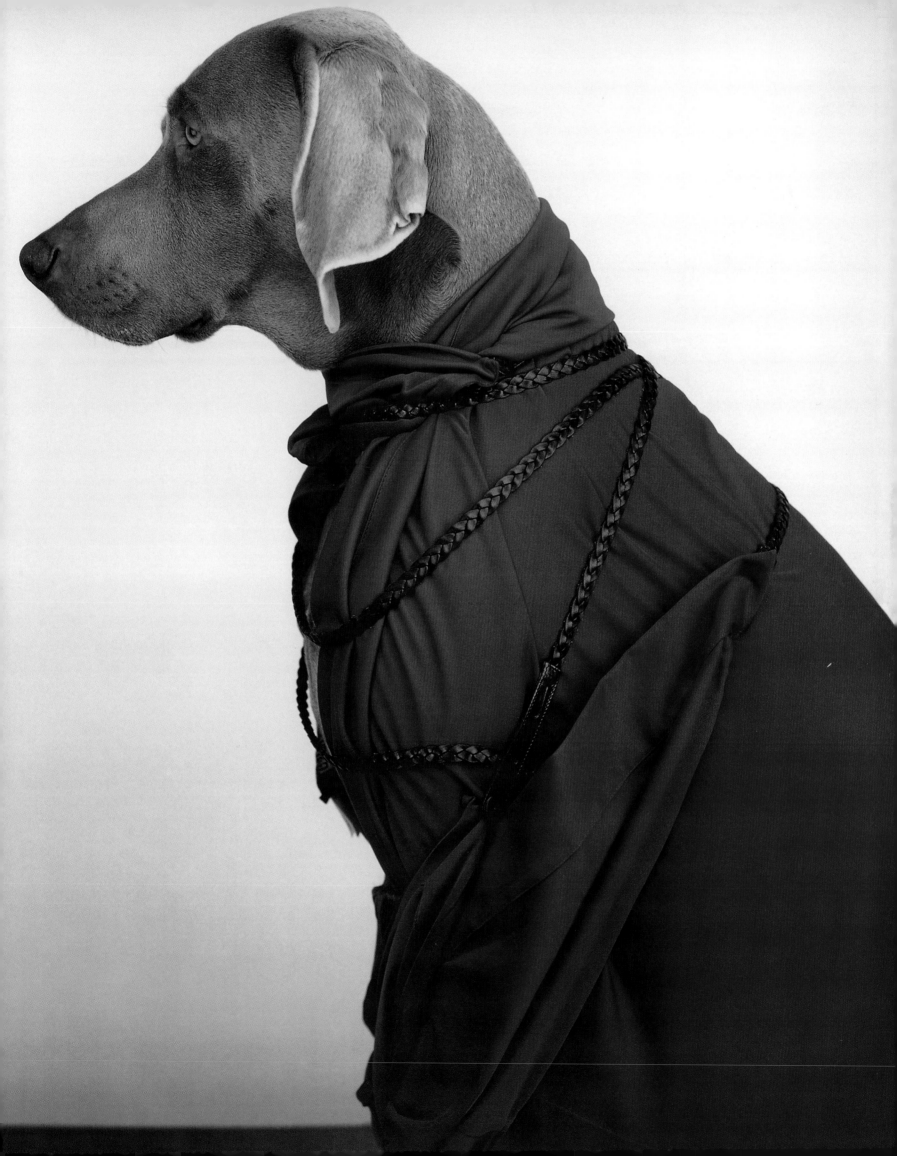

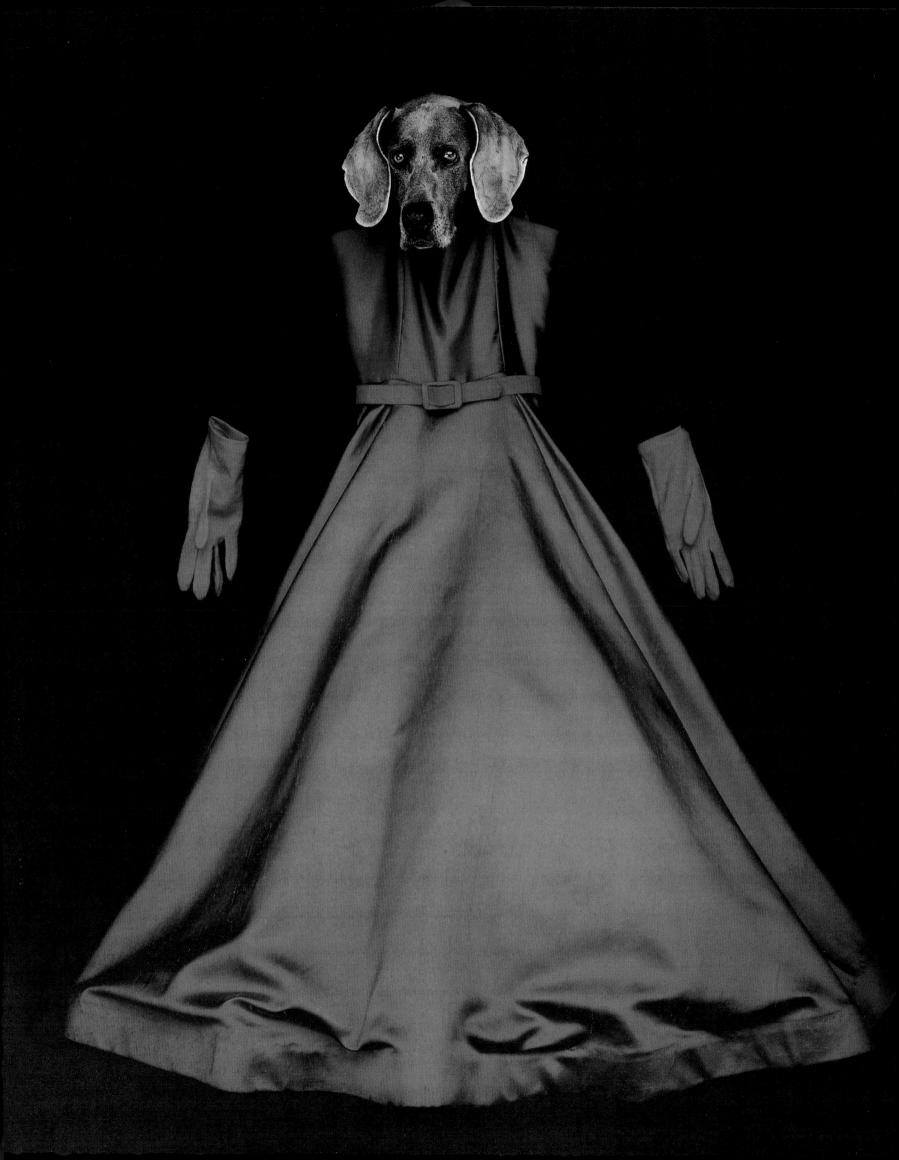

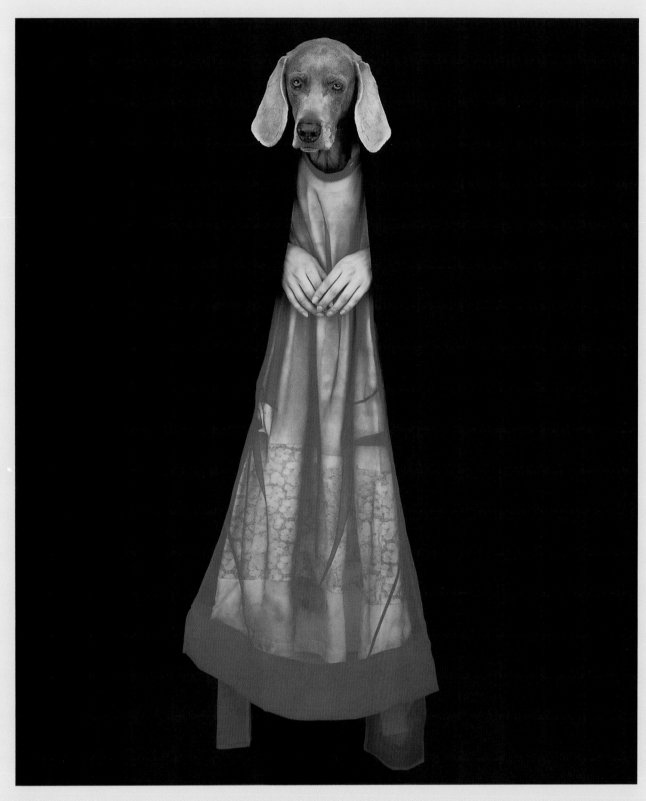

LITTLE RED, 1999

RED RIG, 1999

SCOTTY, 1999

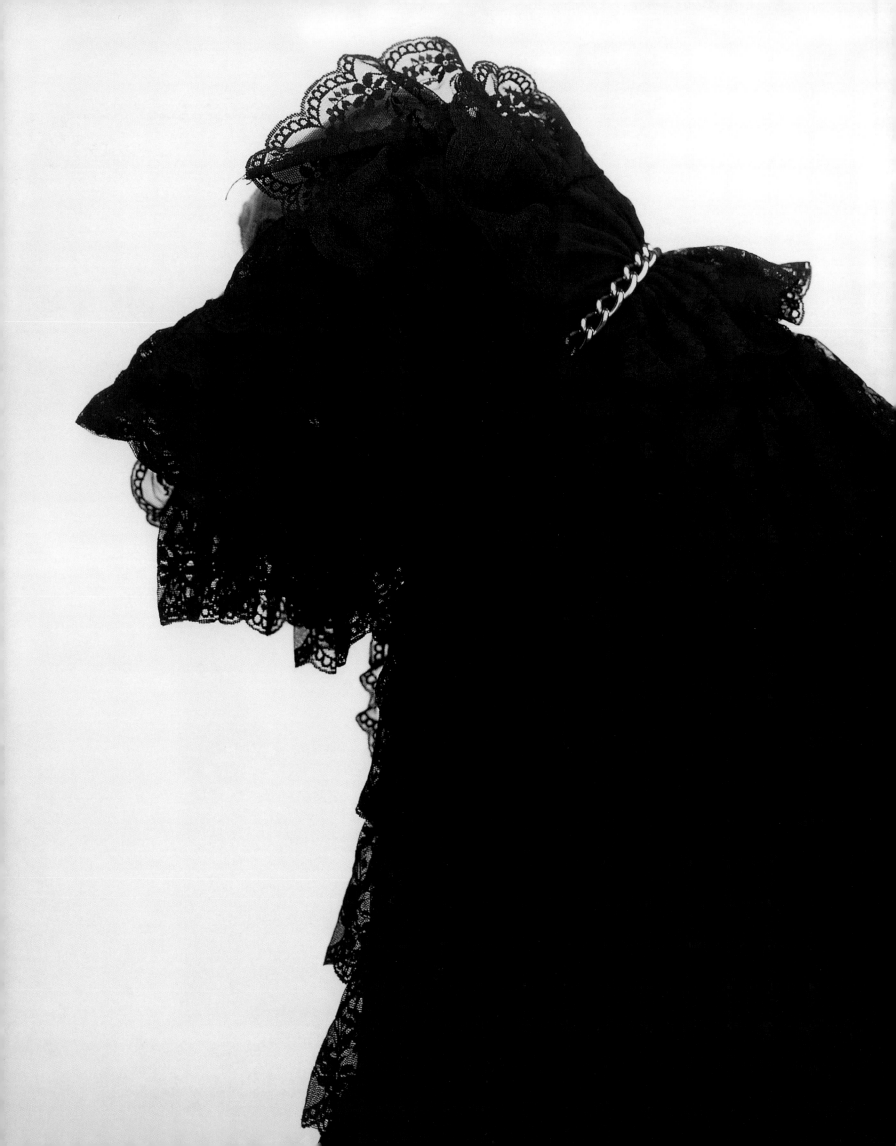

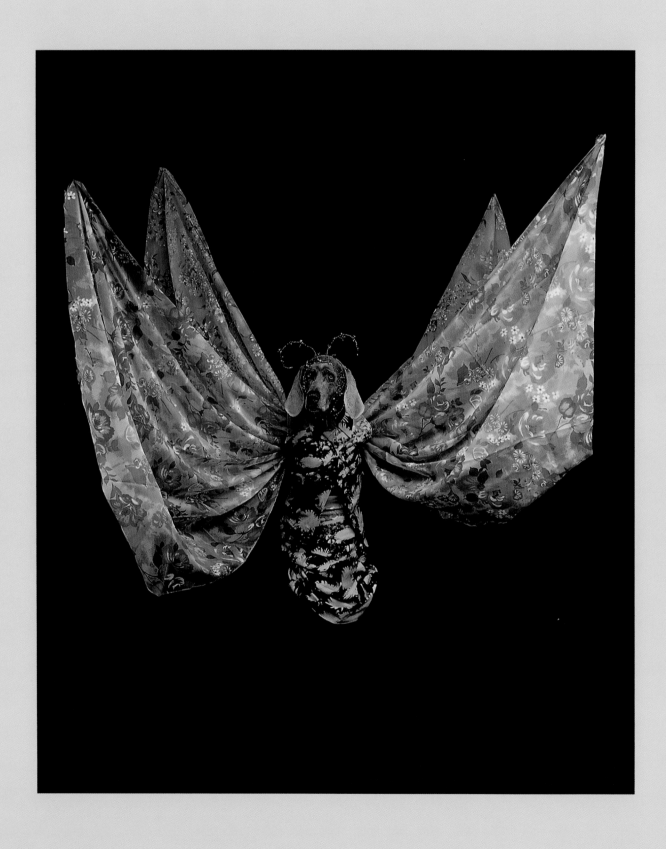

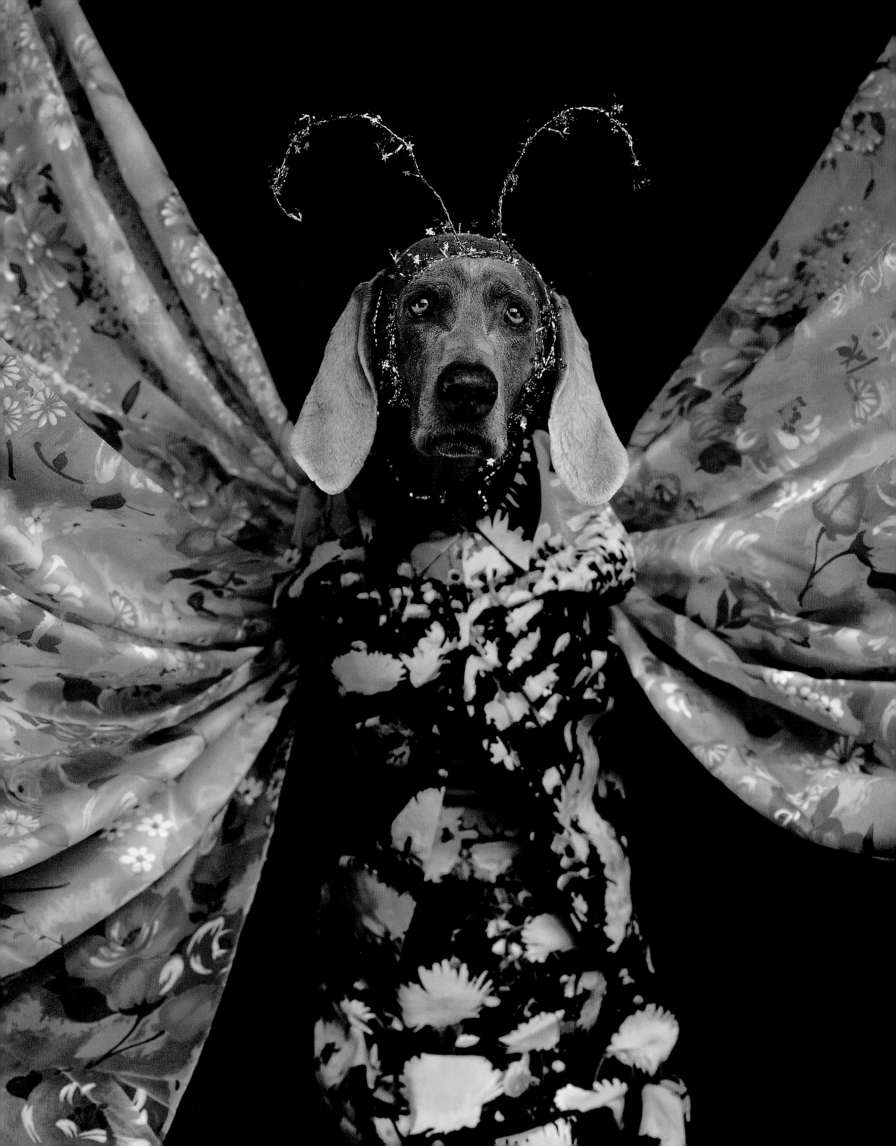

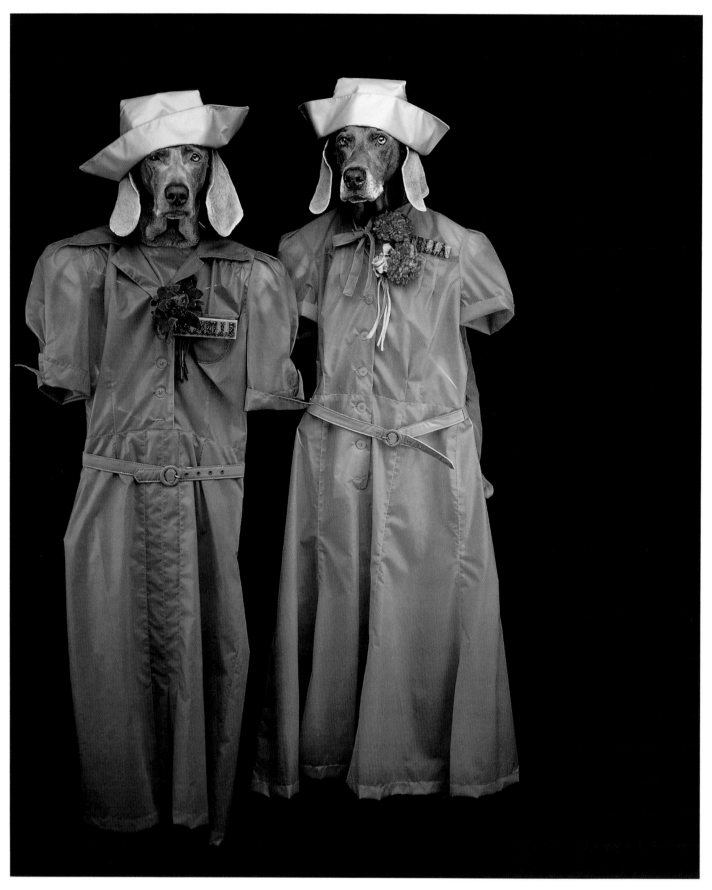

NURSE, NURSE, 1994

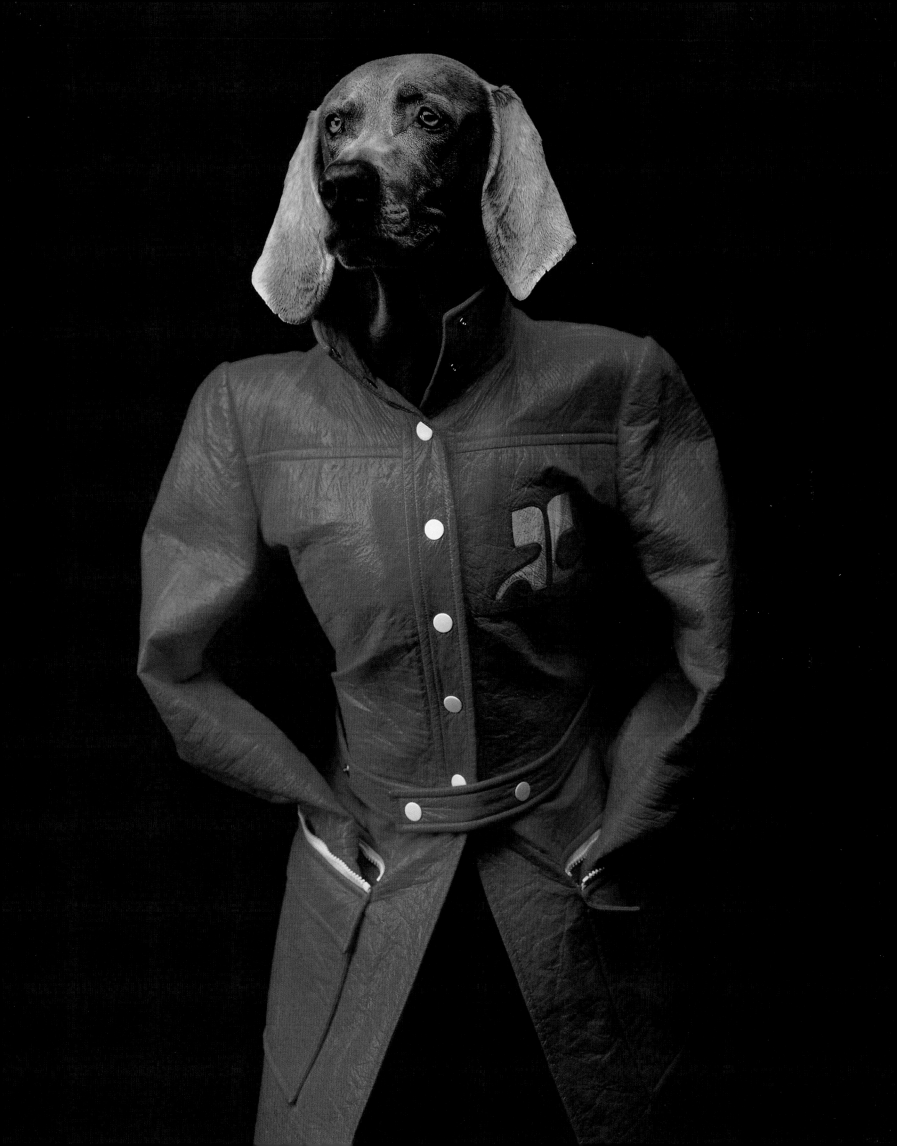

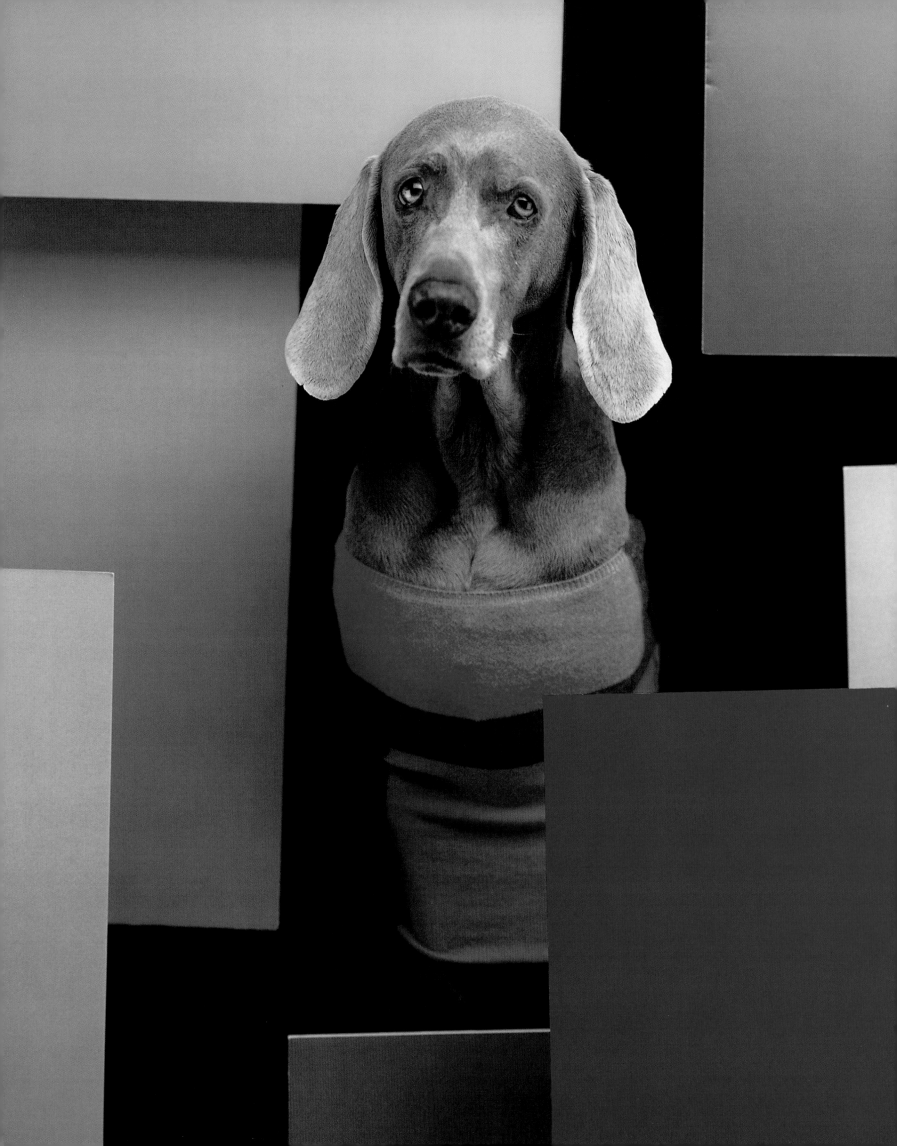

IN THE BAUHAUS, 1999

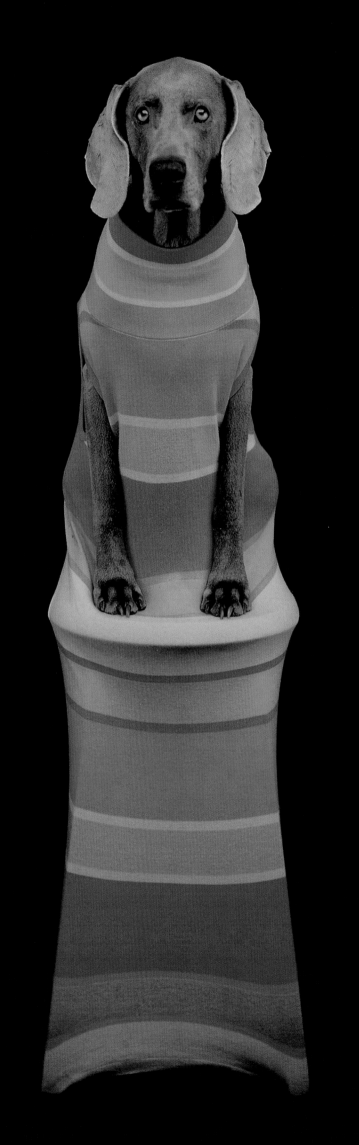

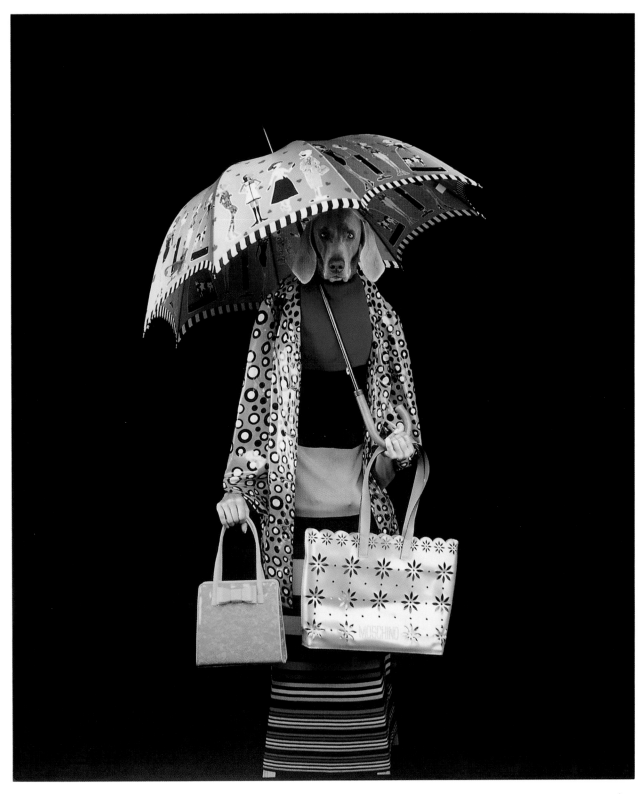

OUTING, 1996

PARFAIT, 1996

VICTORY, 1999

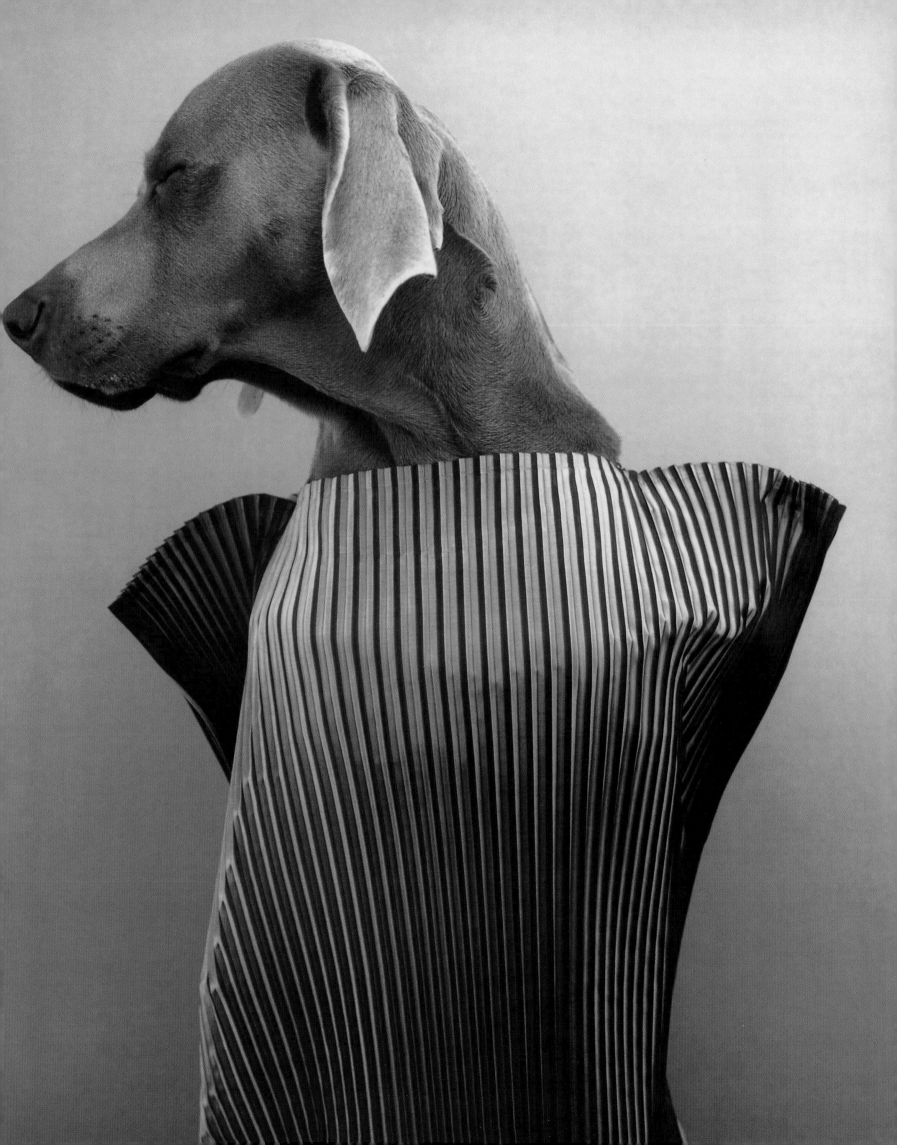

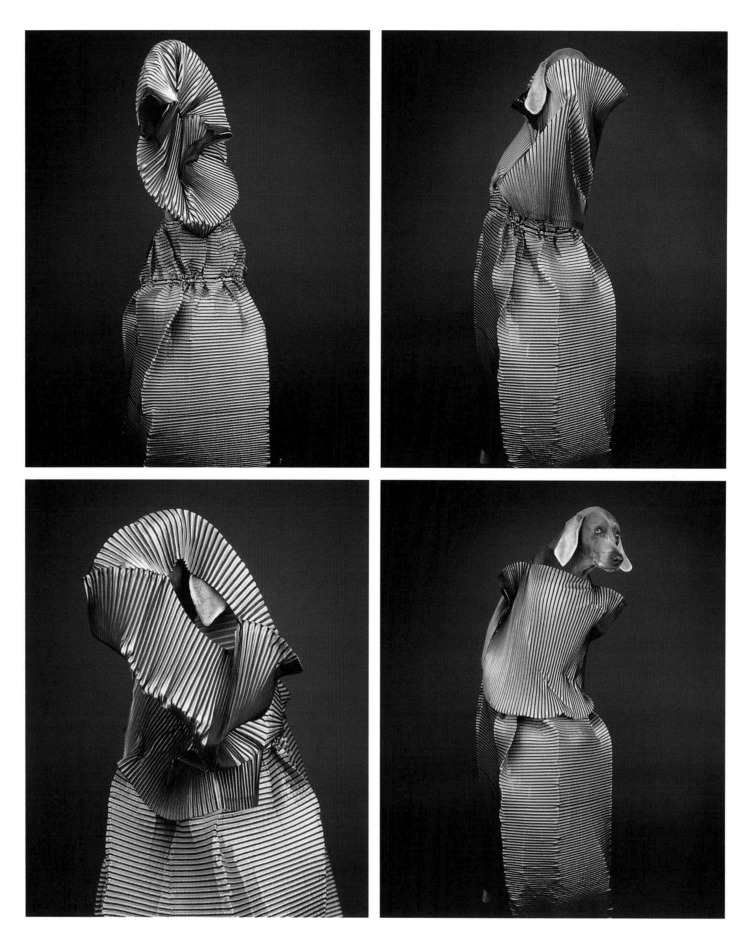

EVOLUTION OF A BOTTLE IN SPACE, 1999

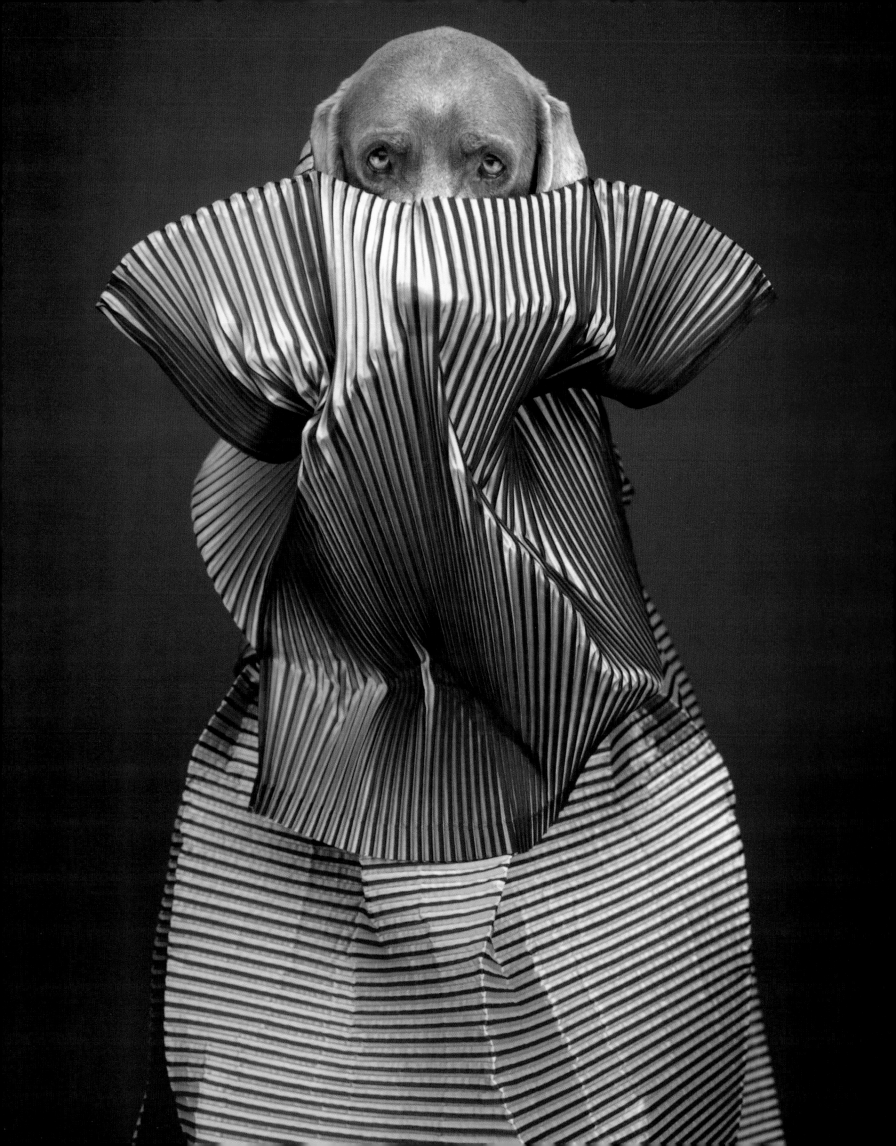

HOUSE OF MIYAKE, 1999

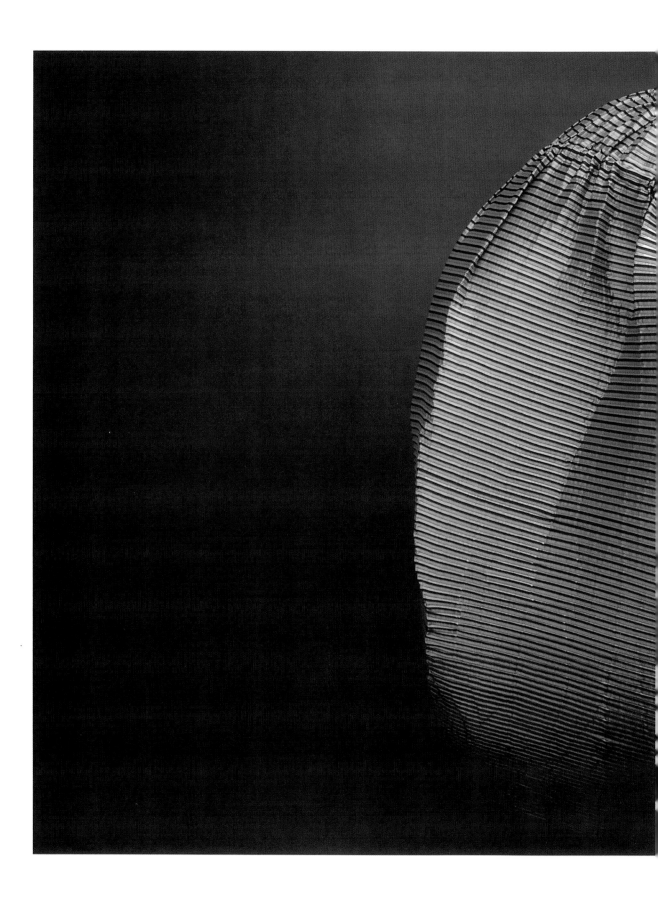

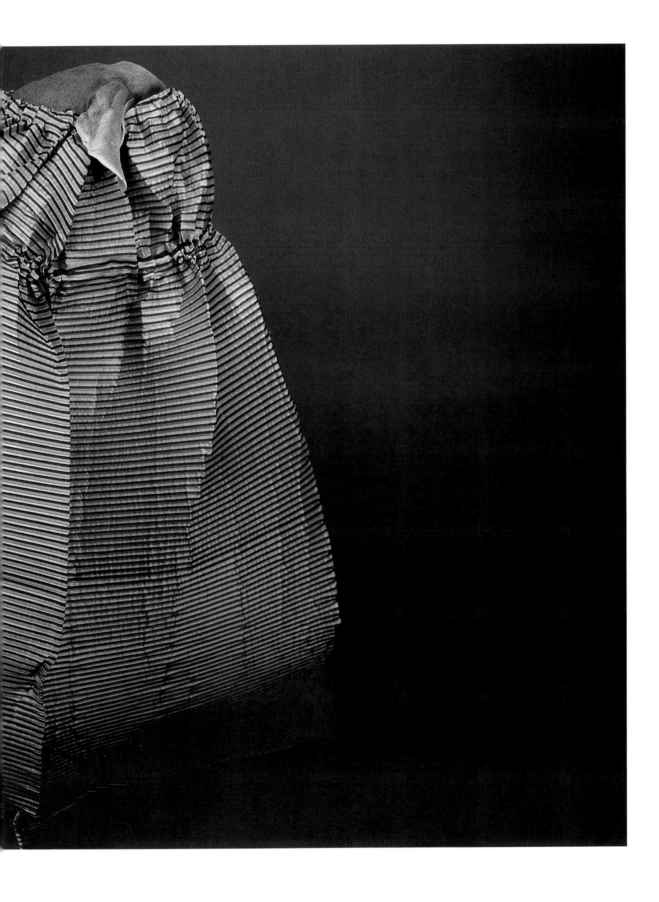

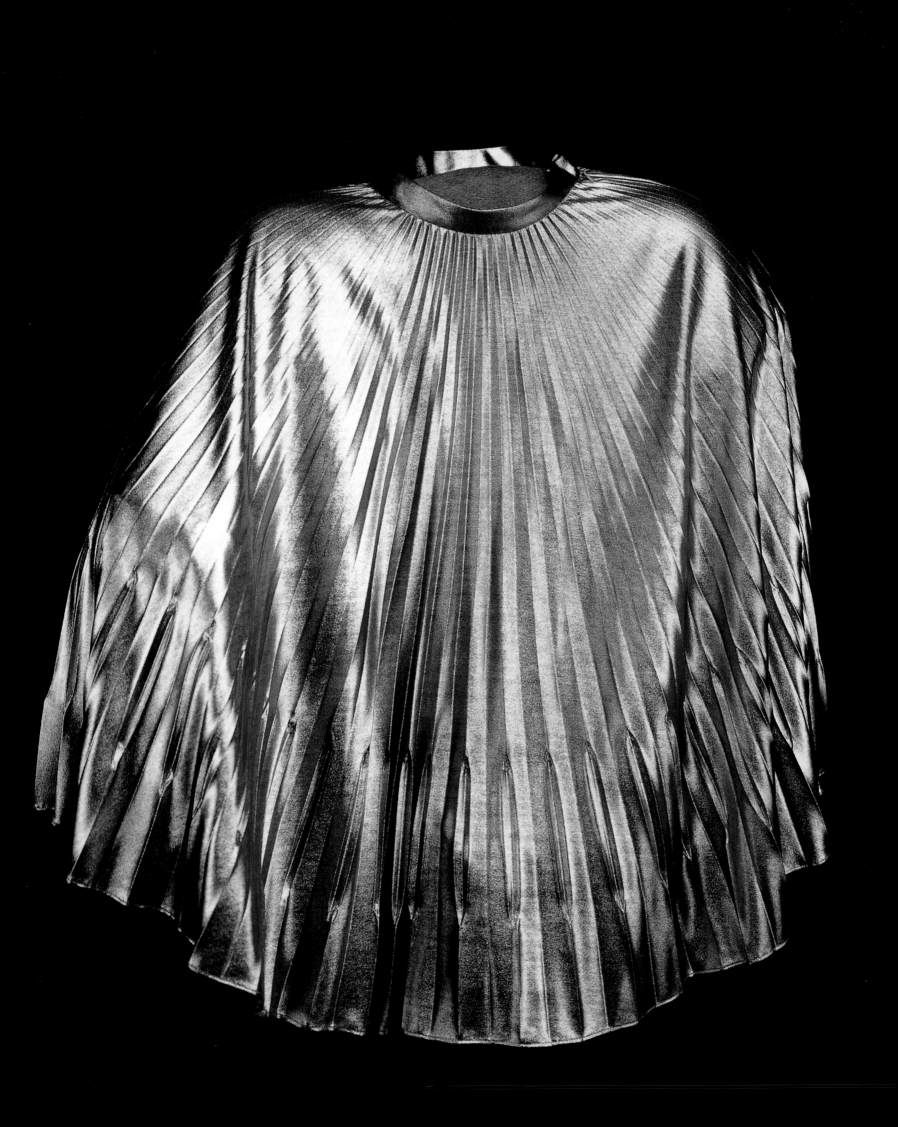

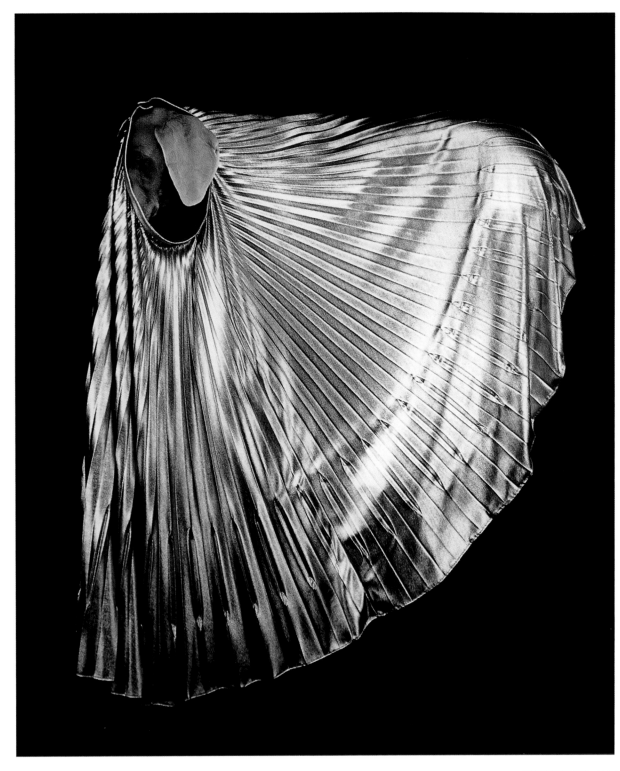

COCKLESHELL, 1994

DUCT, 1994

SUMMER COTTAGE, 1999

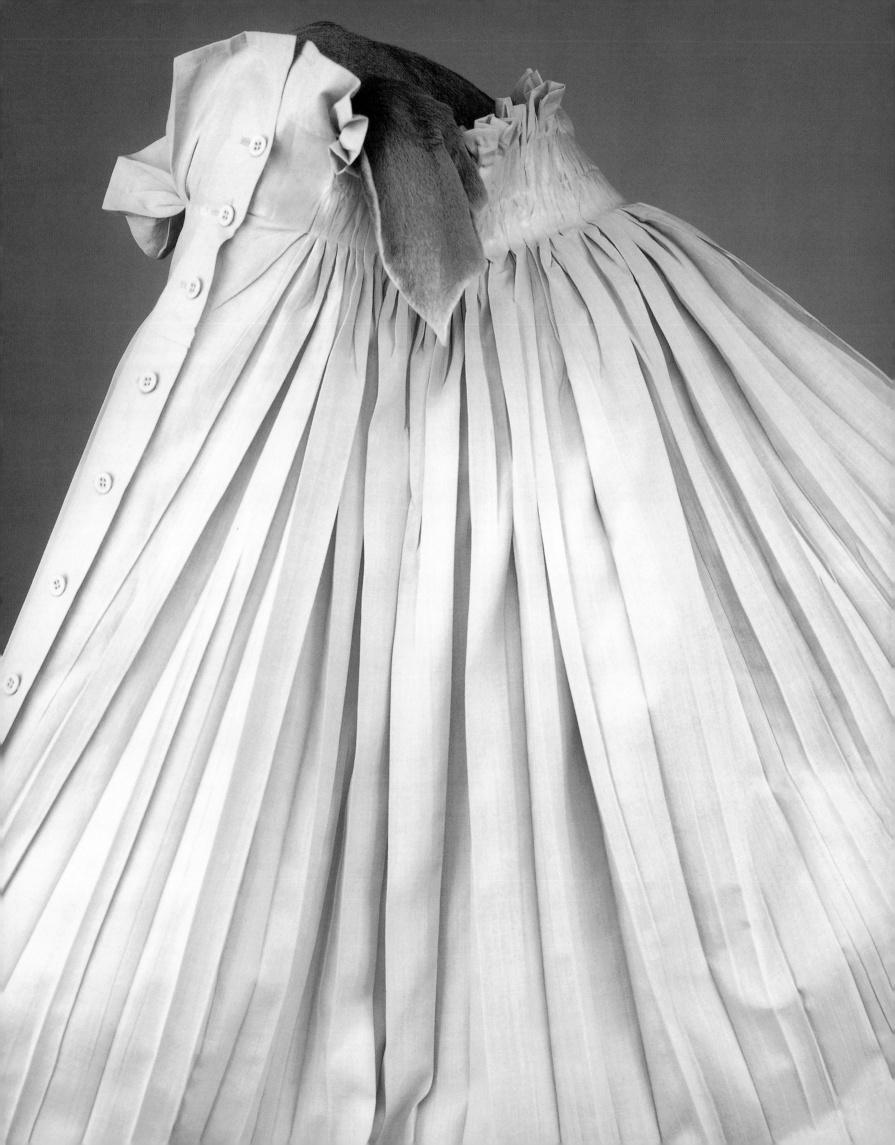

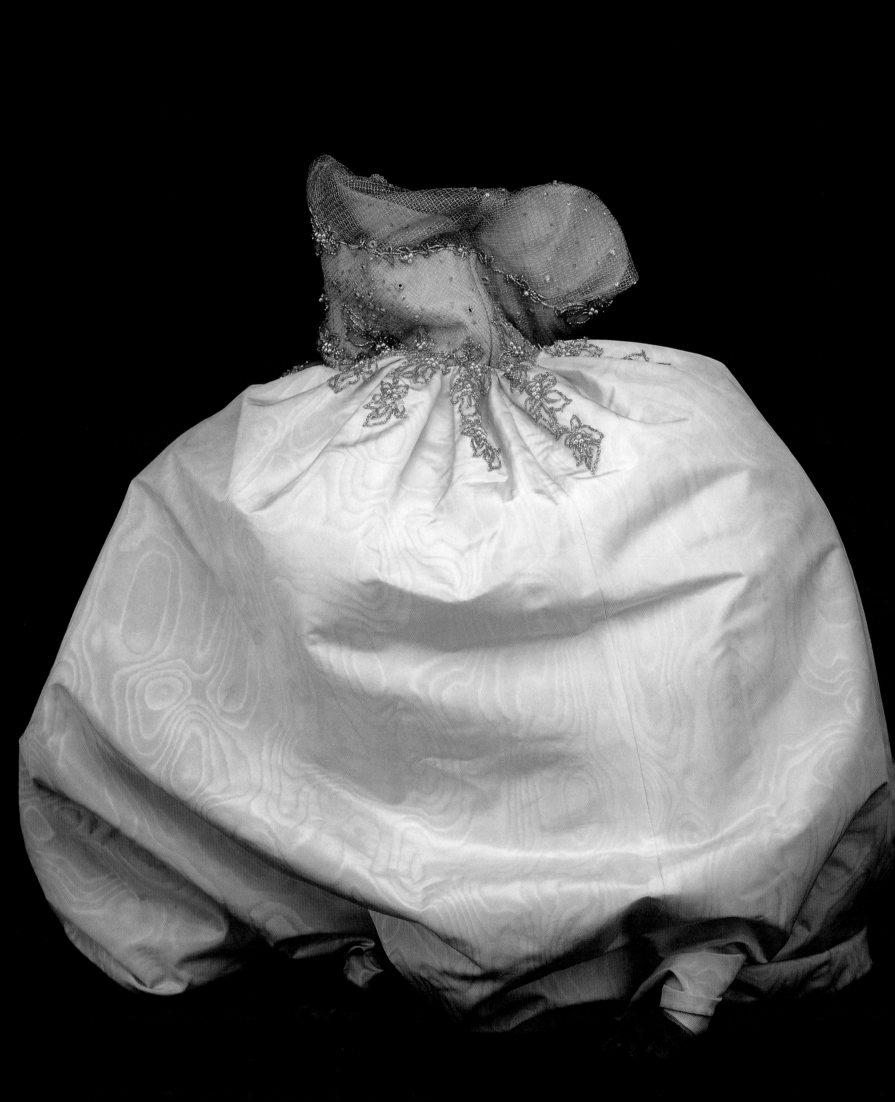

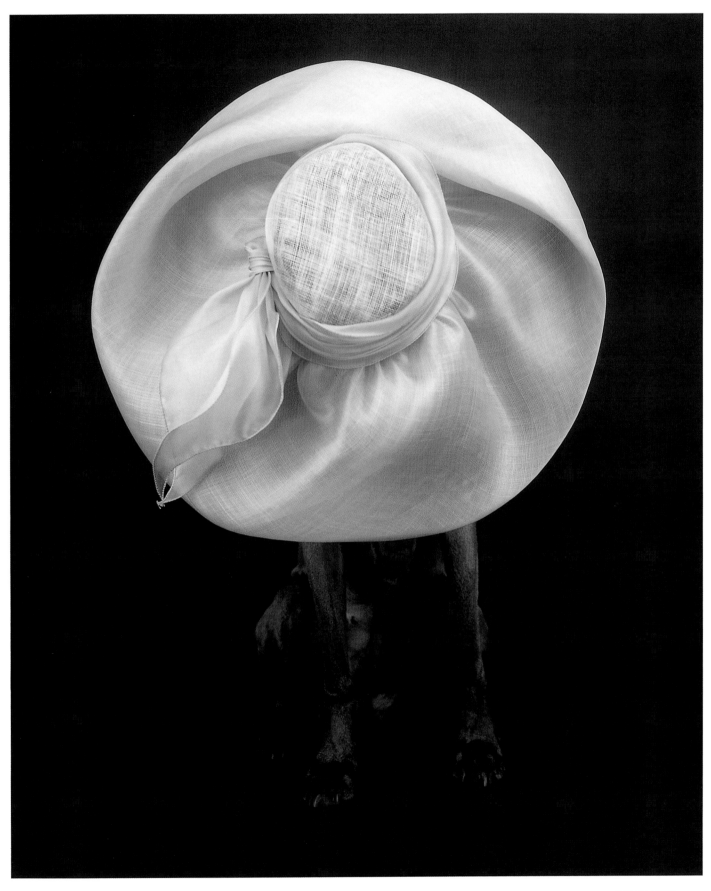

CREAM PUFF, 1999

DESSERT, 1999

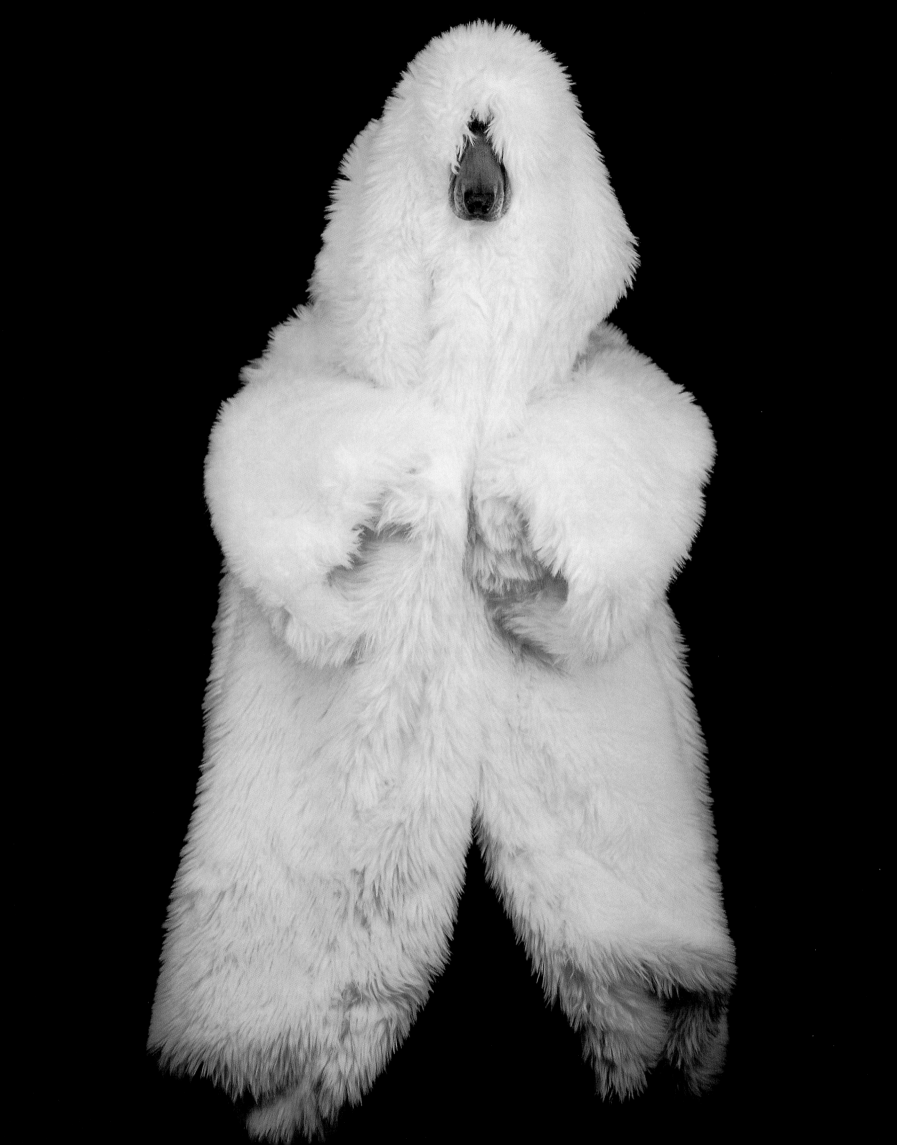

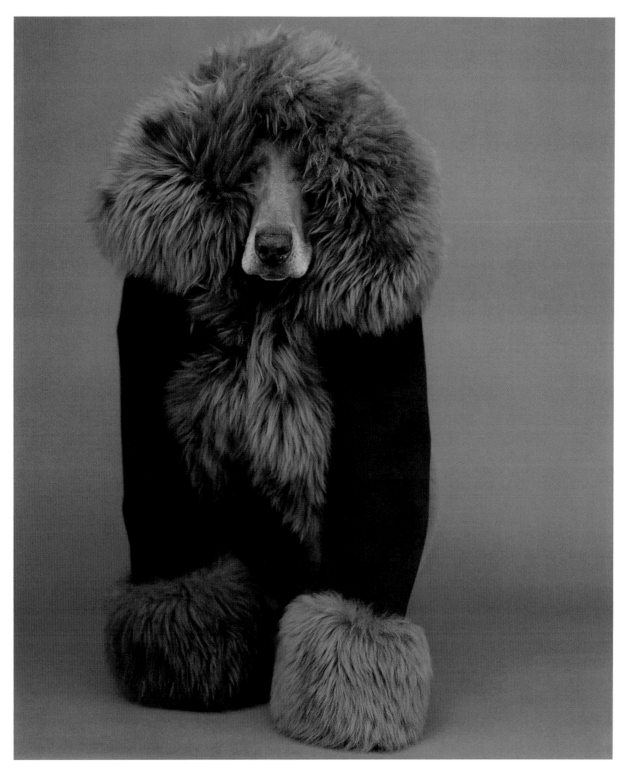

BLUE POWDER, 1994

POLAR EXTREME, 1994

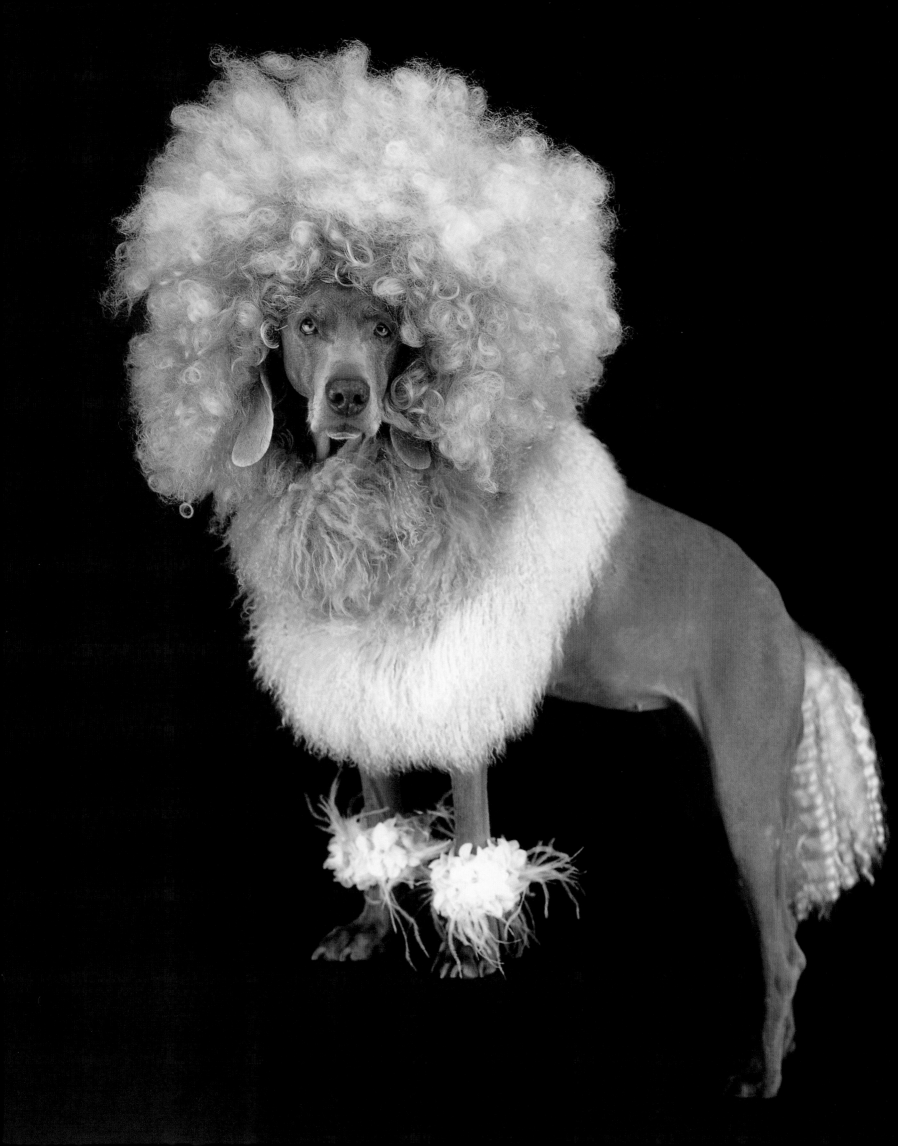

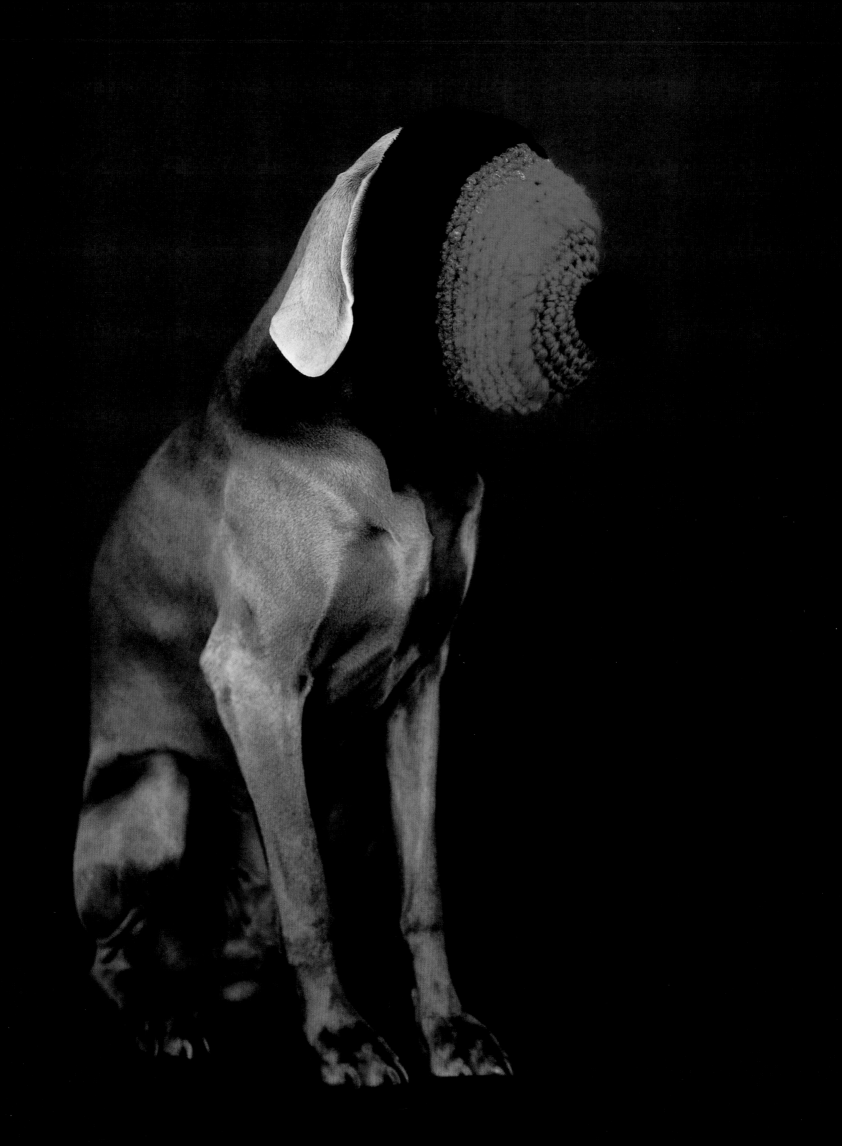

COLLIE, 1994

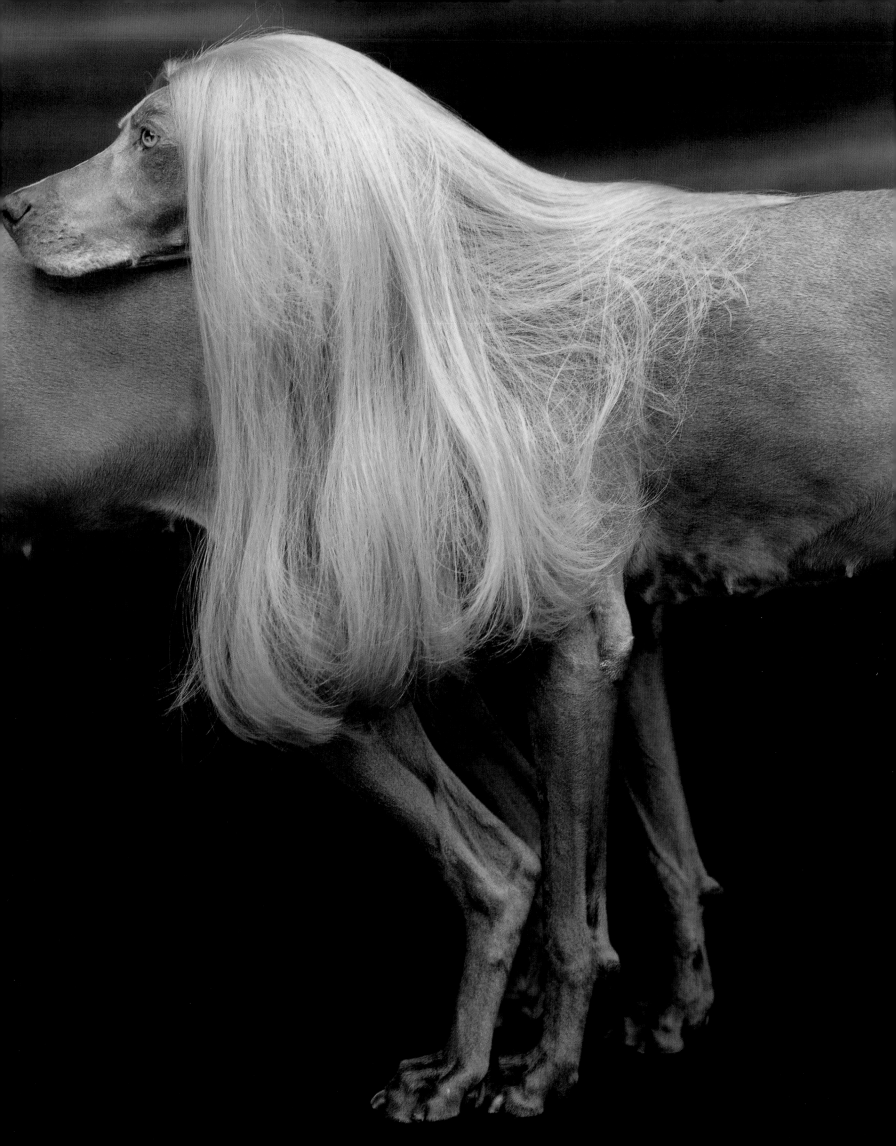

CEREMONIAL HEADWEAR, 1999

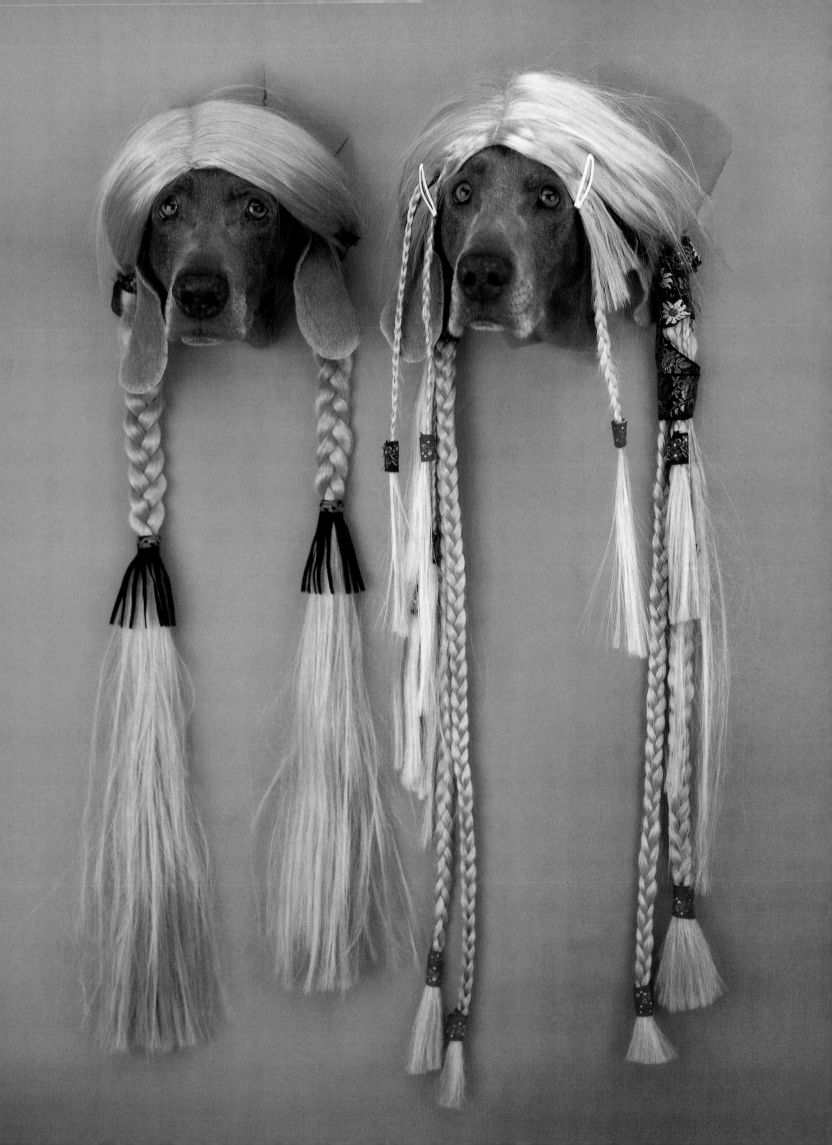

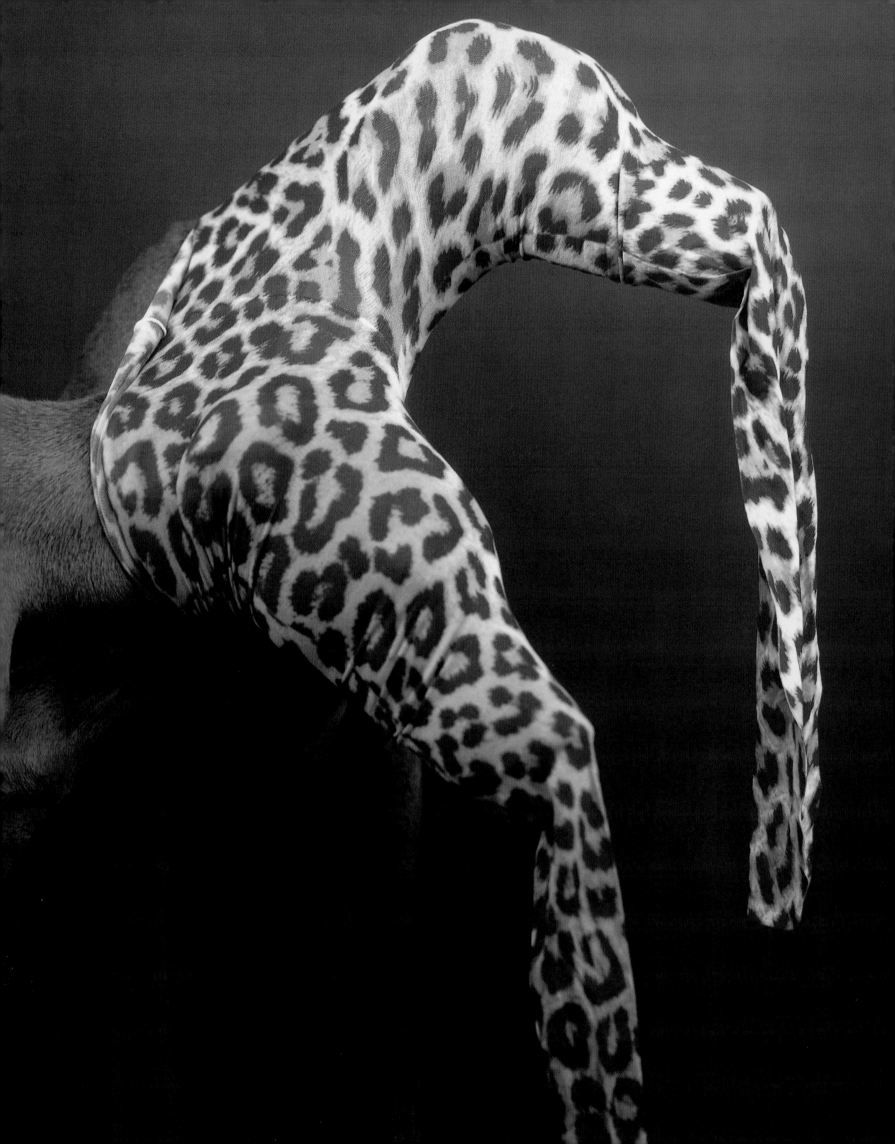

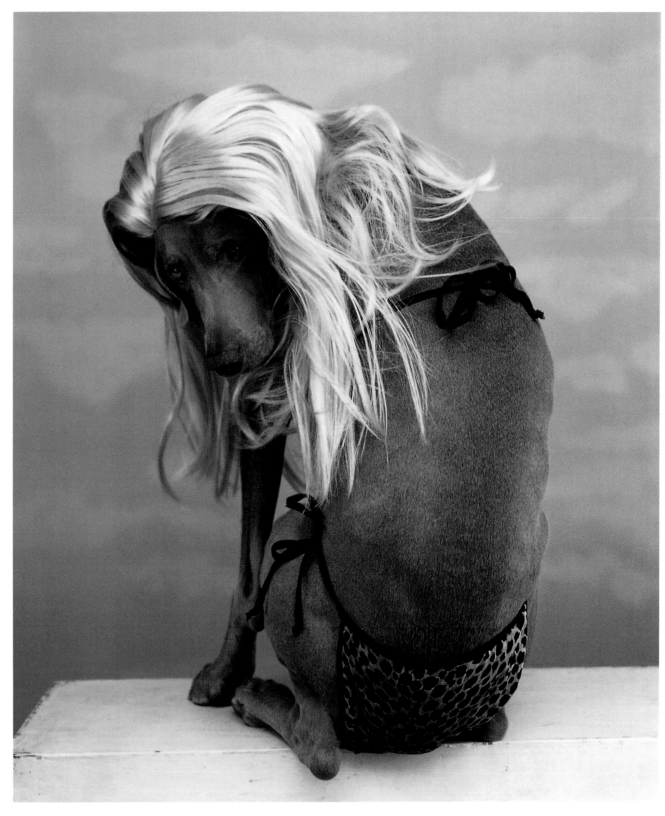

BIKINI, 1999

PANTYASAURUS, 1999

GLAMOUR PUSS, 1999

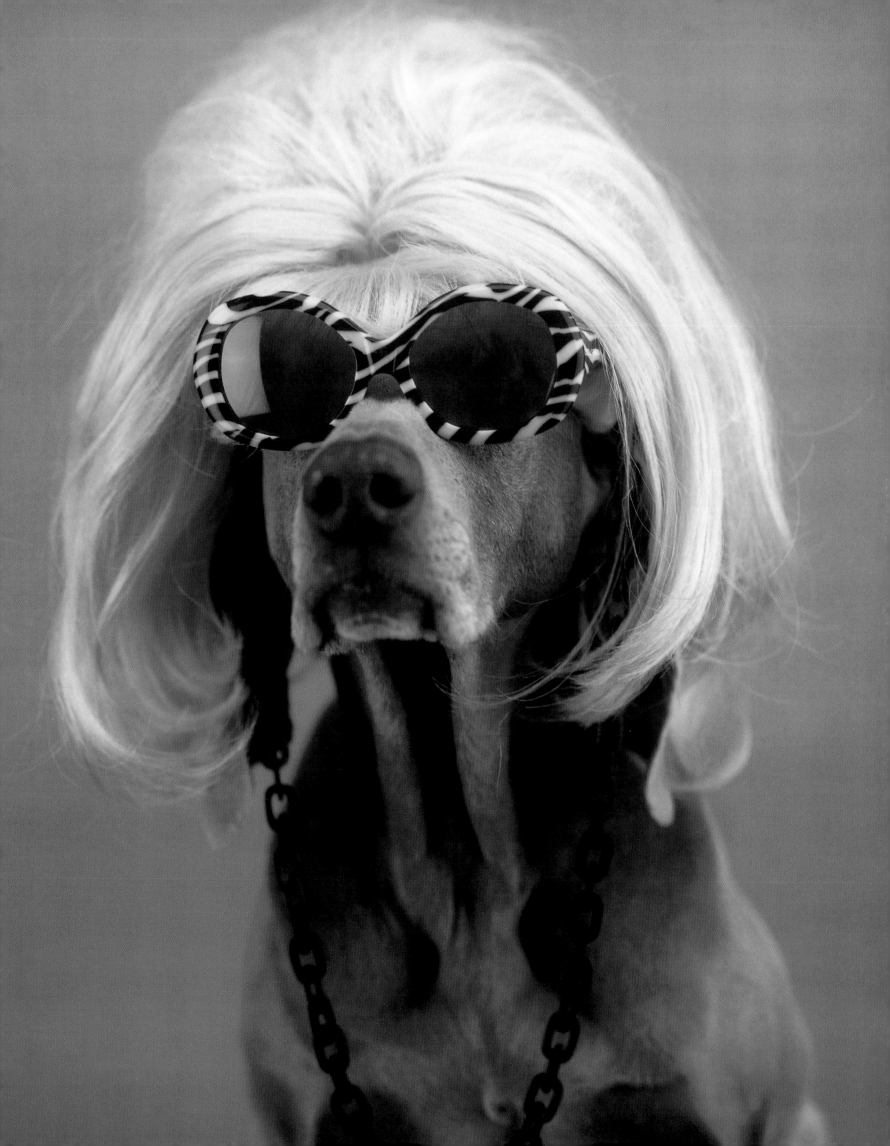

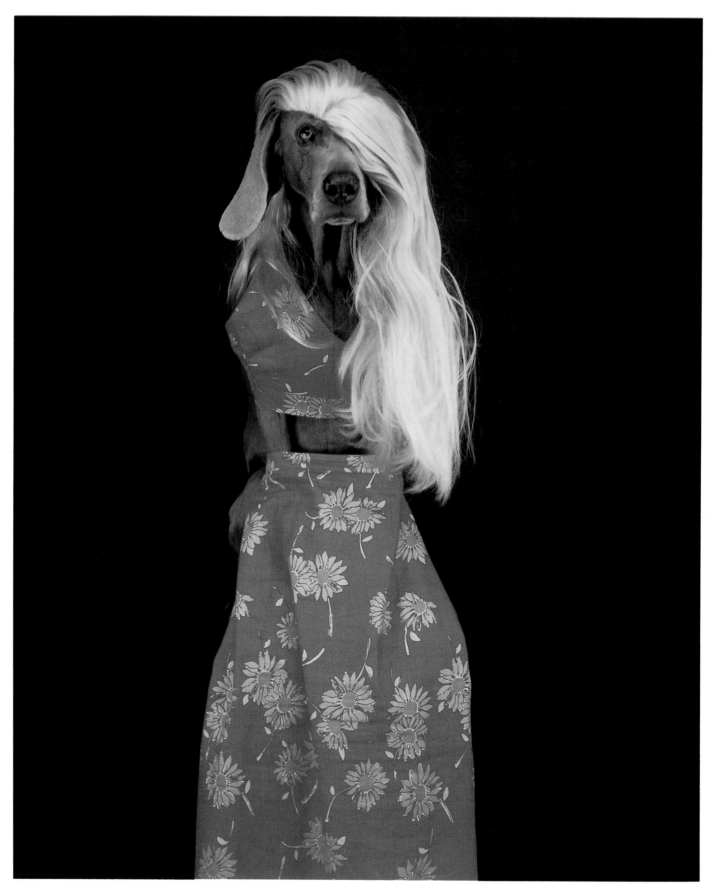

DAISY LEGS, 1999

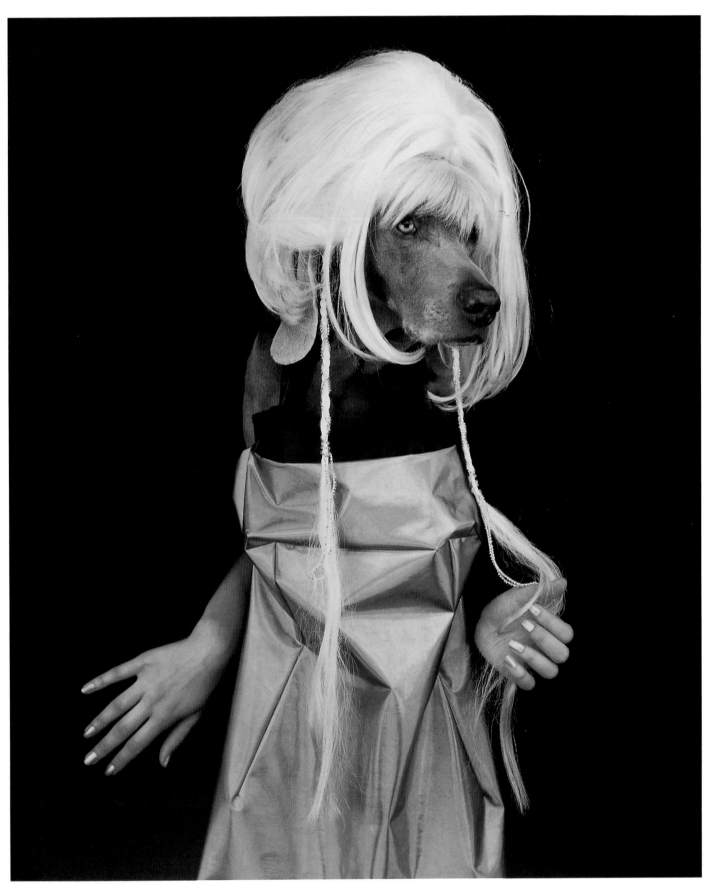

IN THE CUSTODY OF PINK & BLUE, 1999

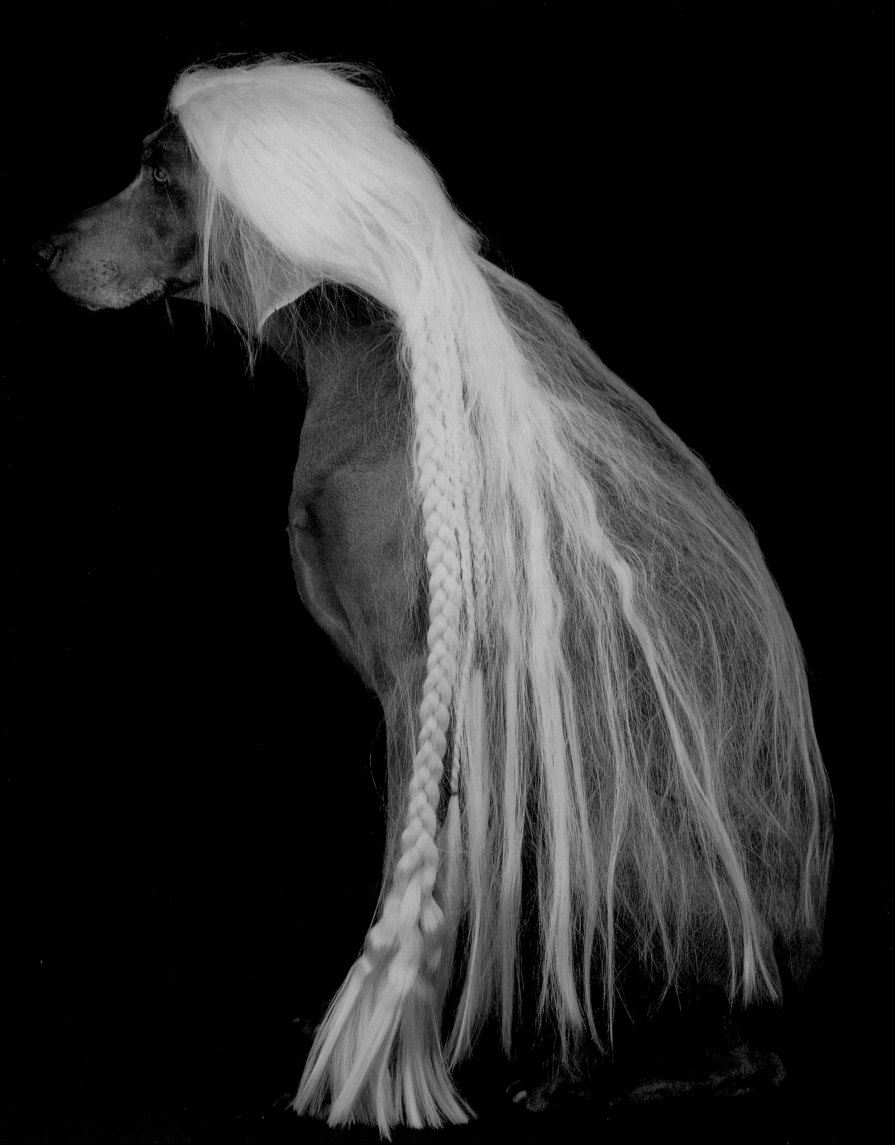

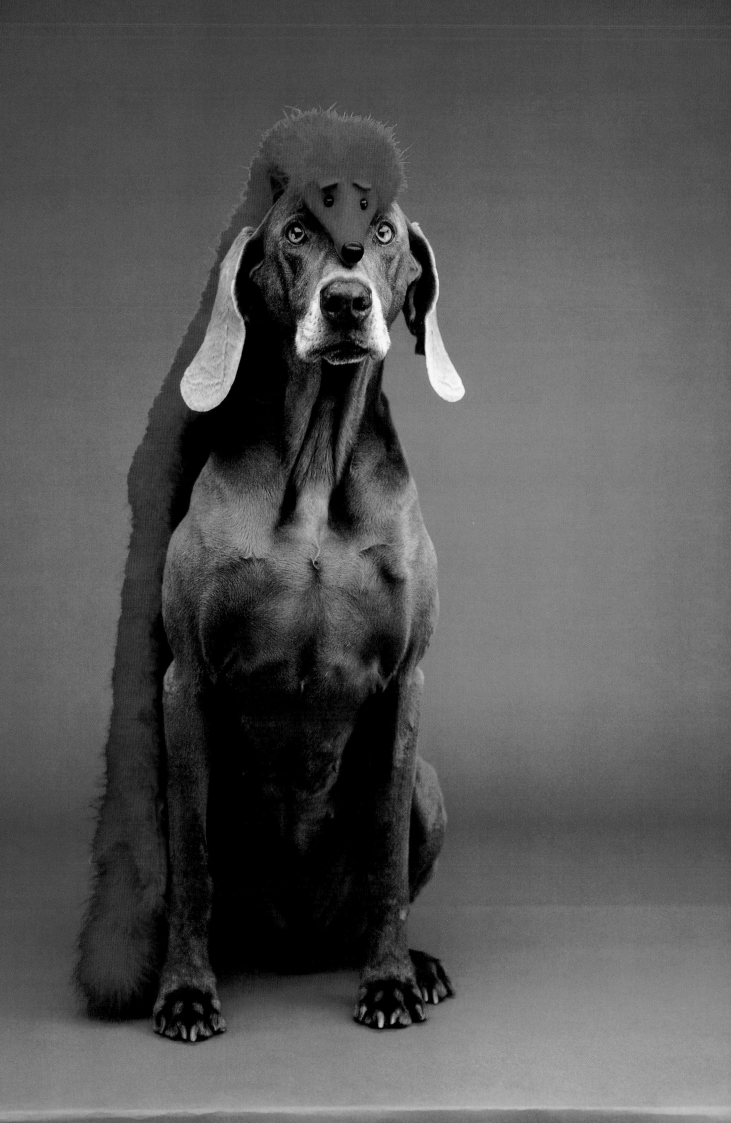

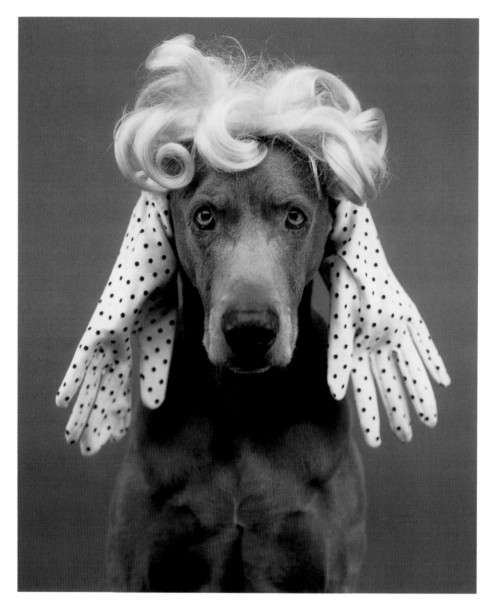

GLOVER, 1999

SPIN SISTERS, 1999

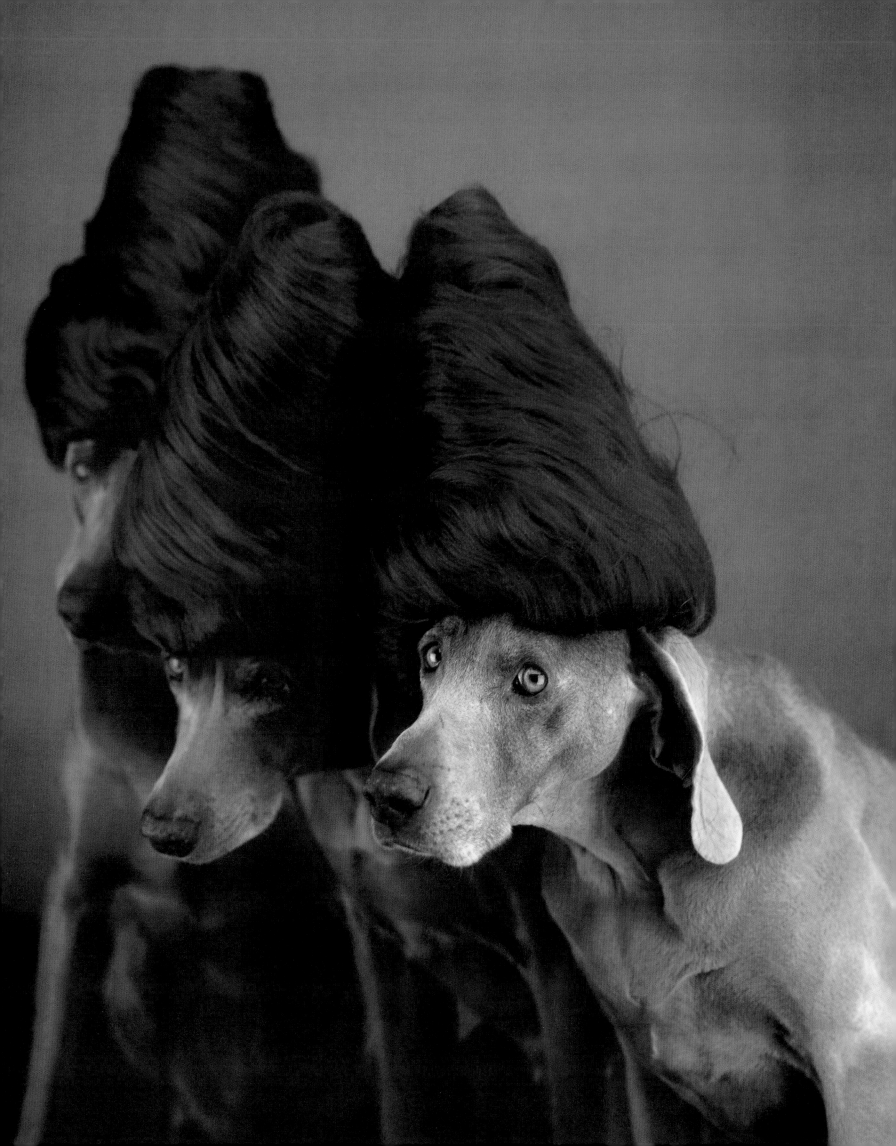

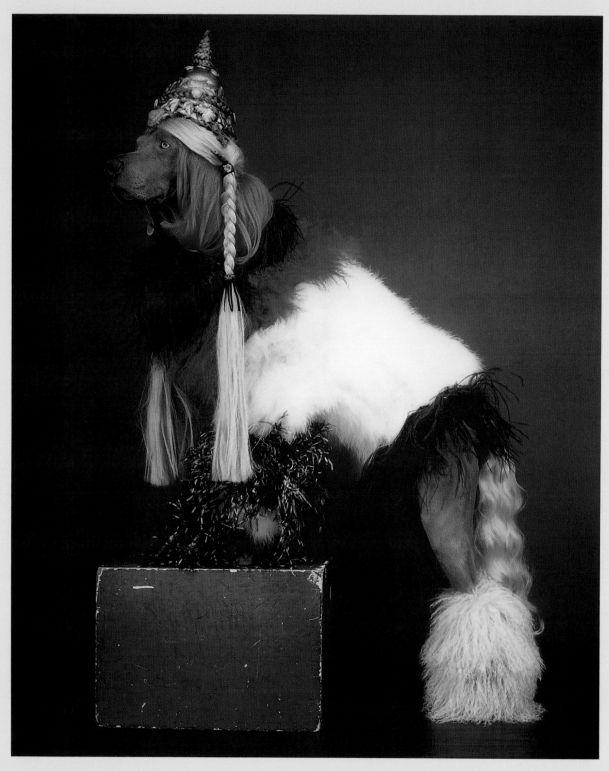

GENGHIS KHAN, 1999

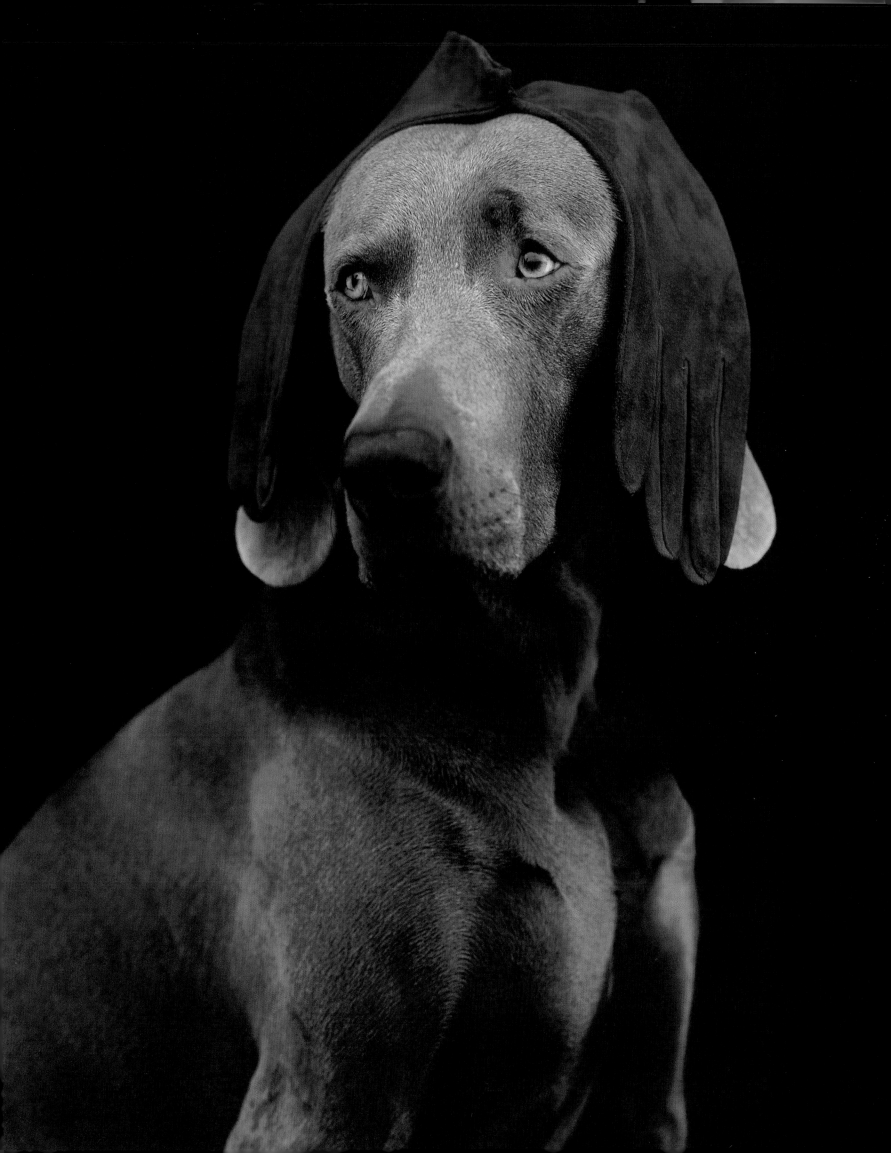

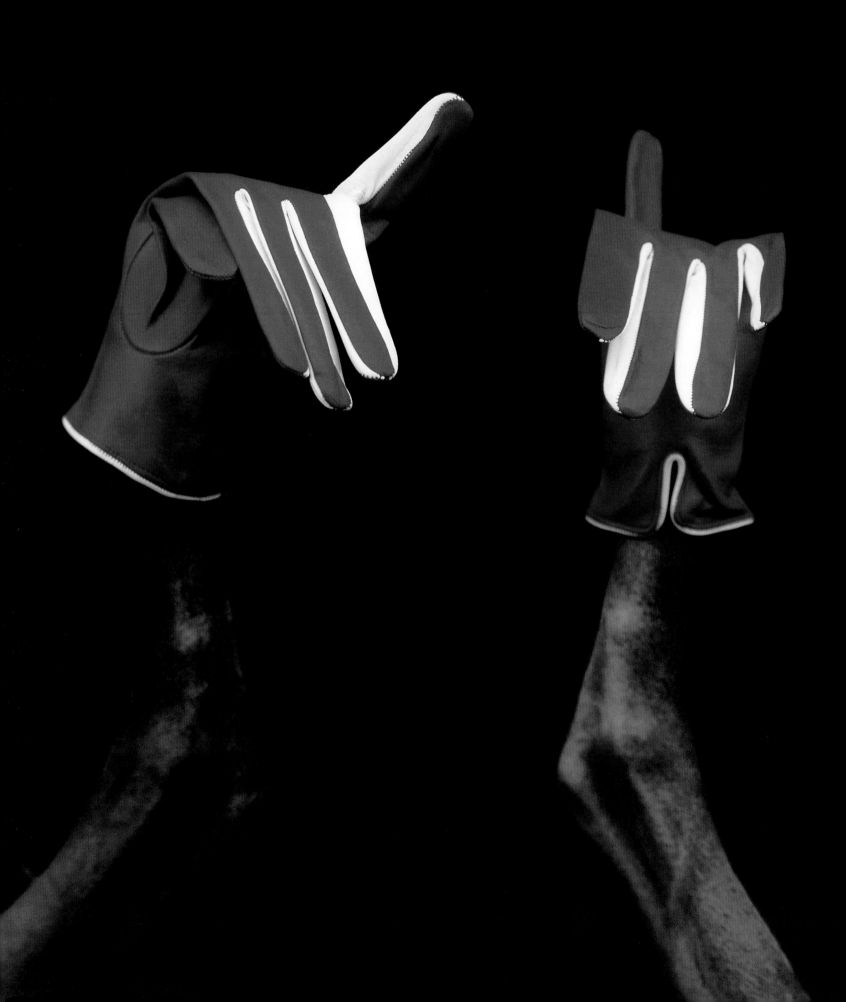

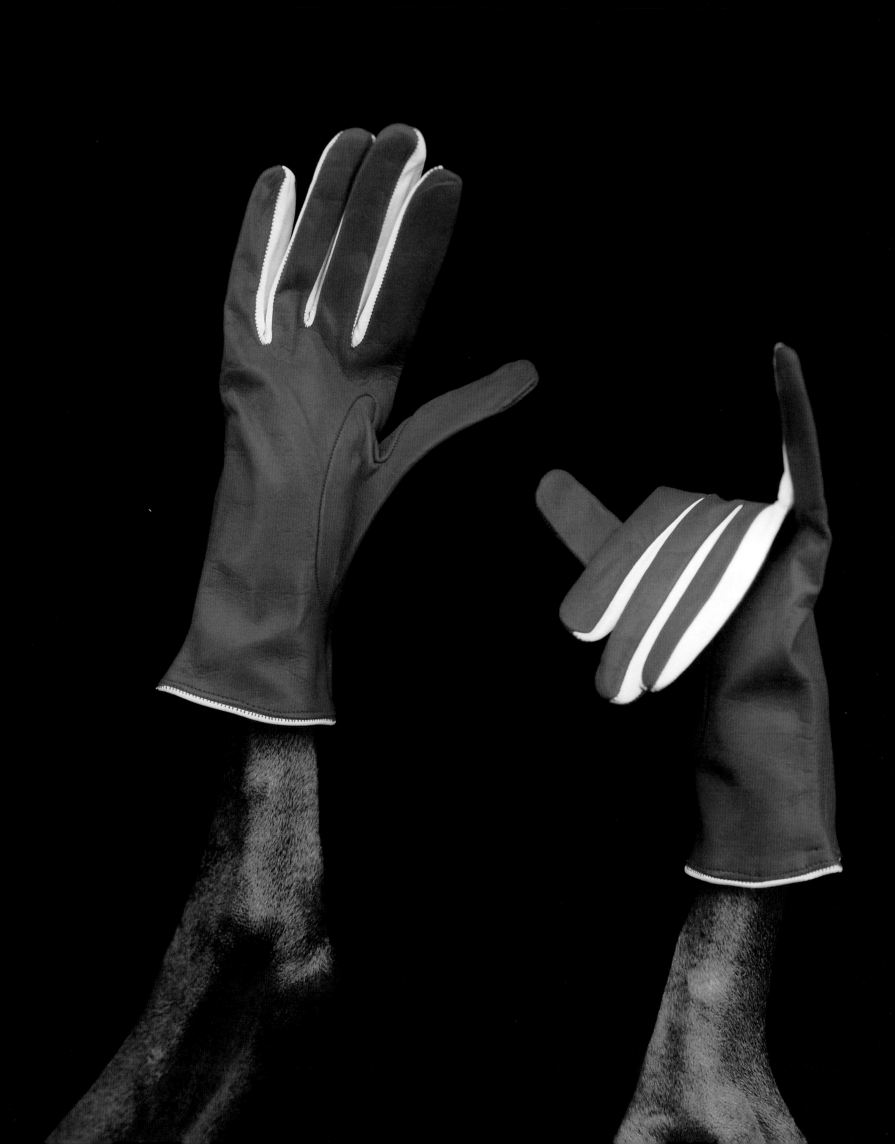

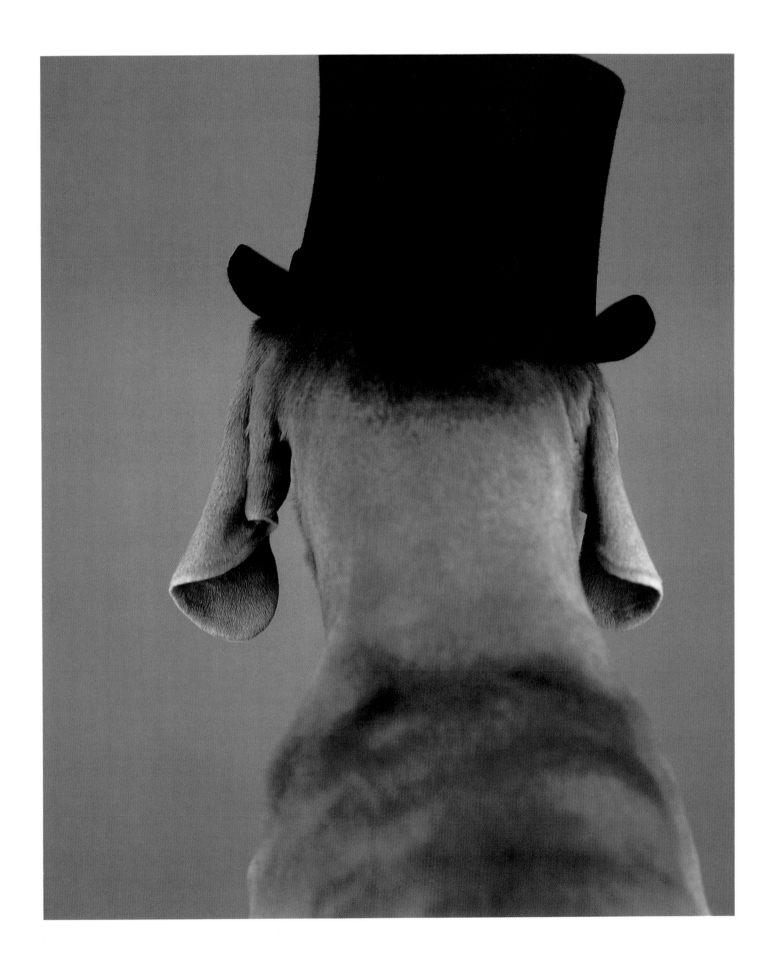

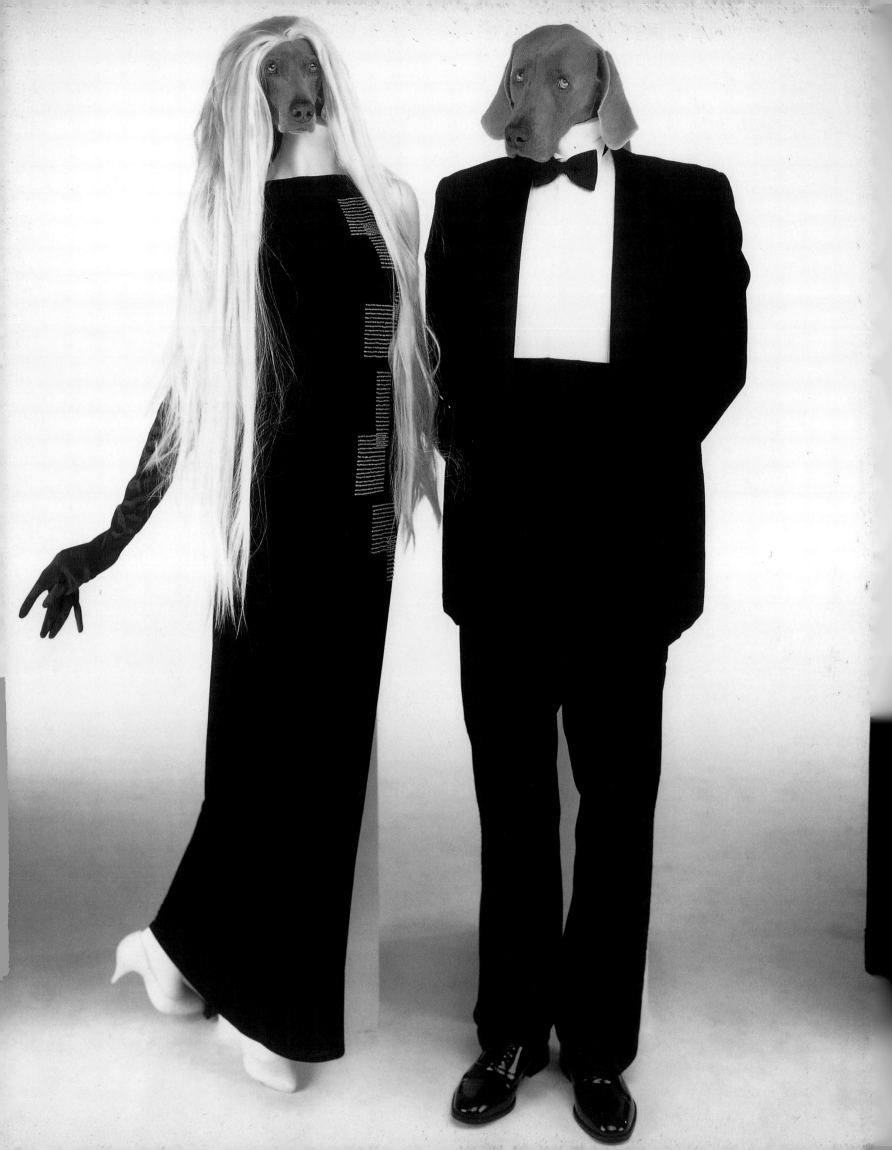

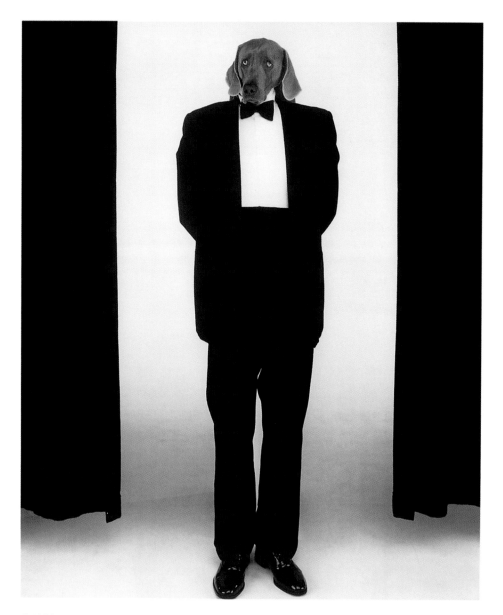

GUEST, 1999

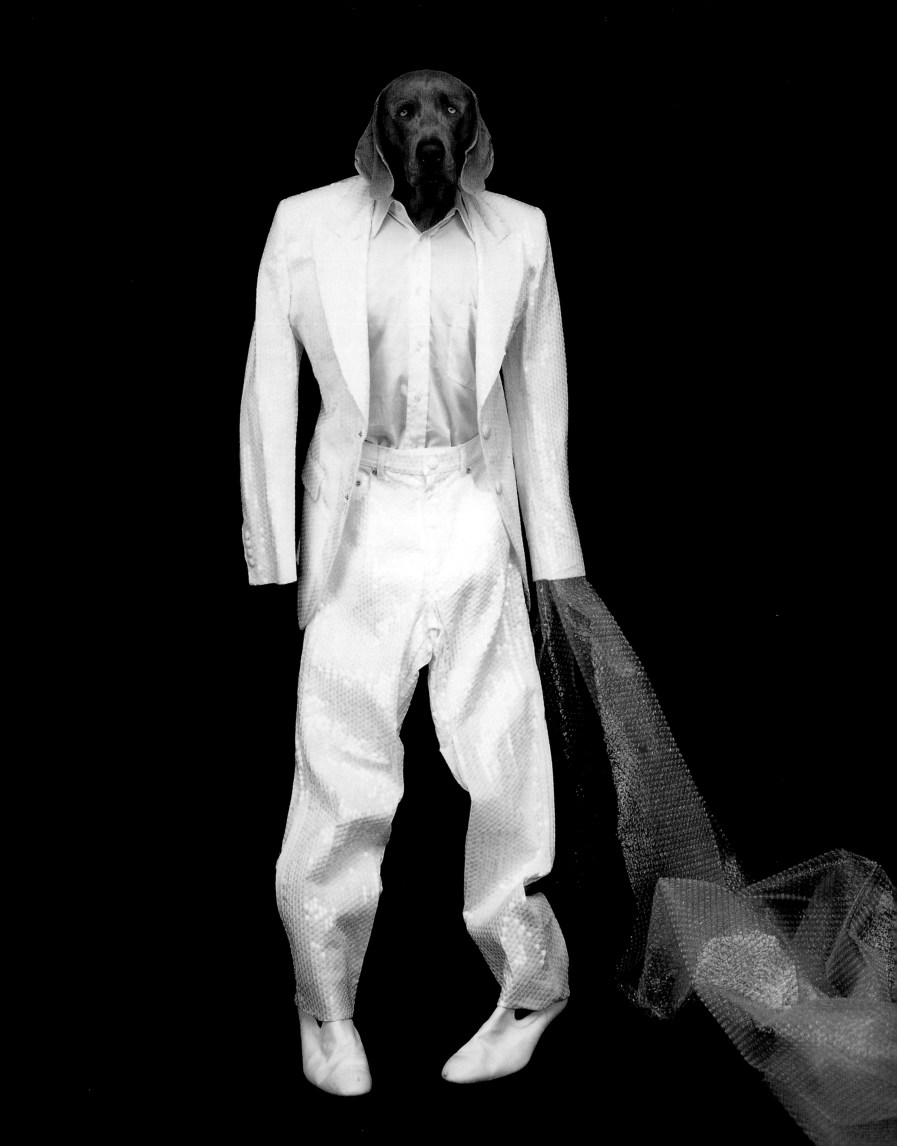

MELISSA, 1994

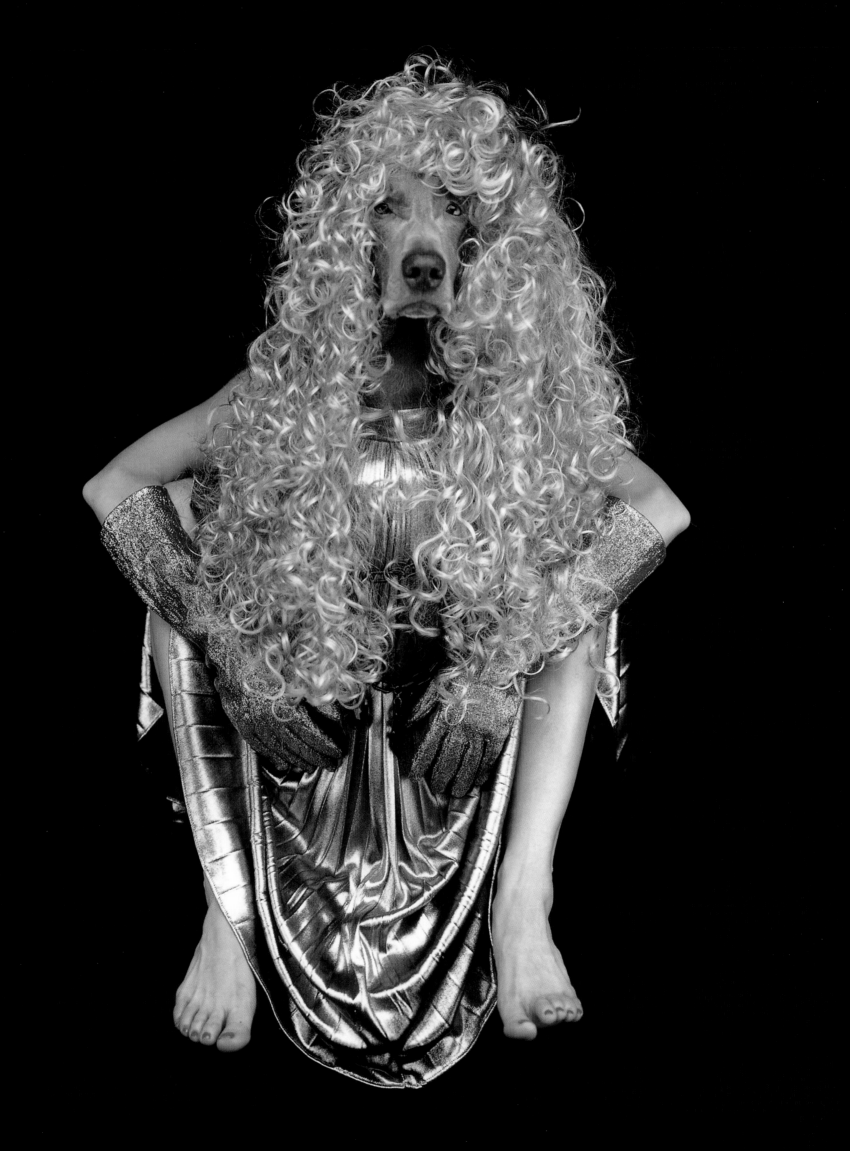

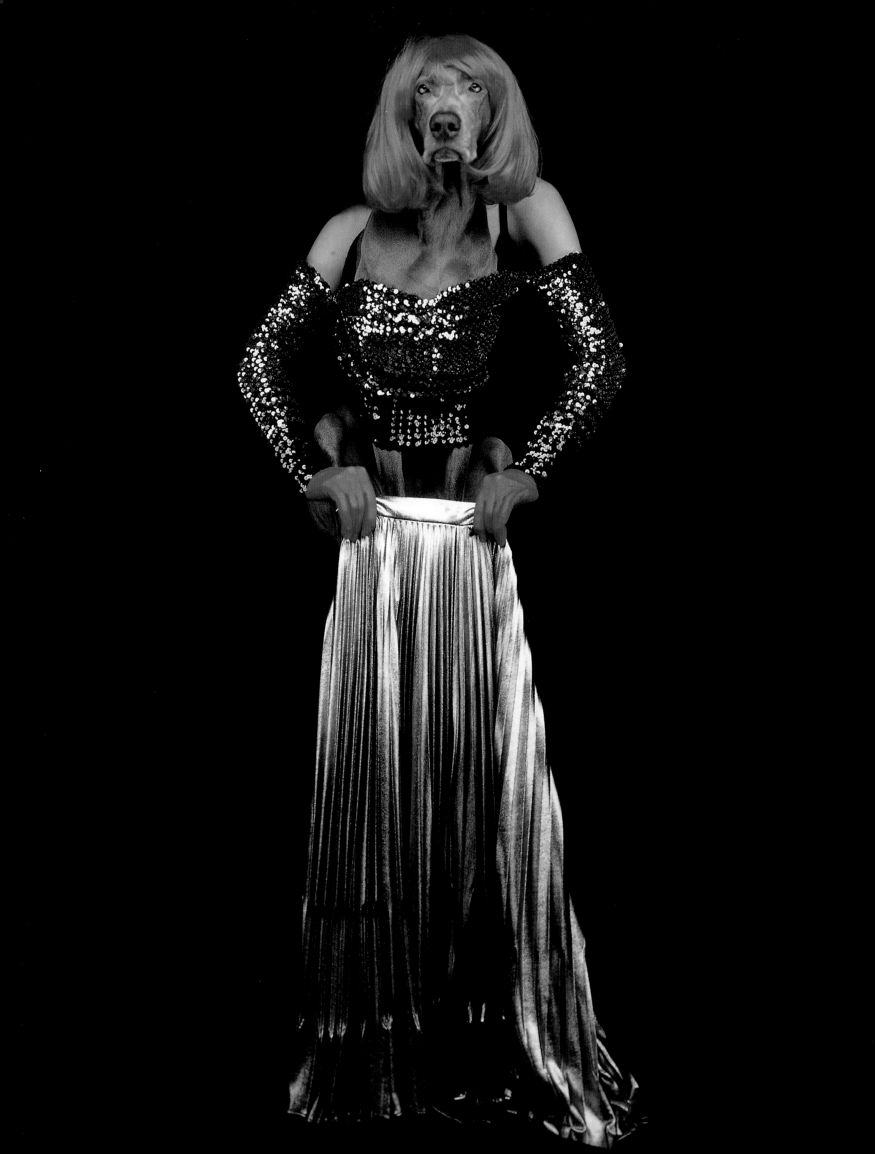

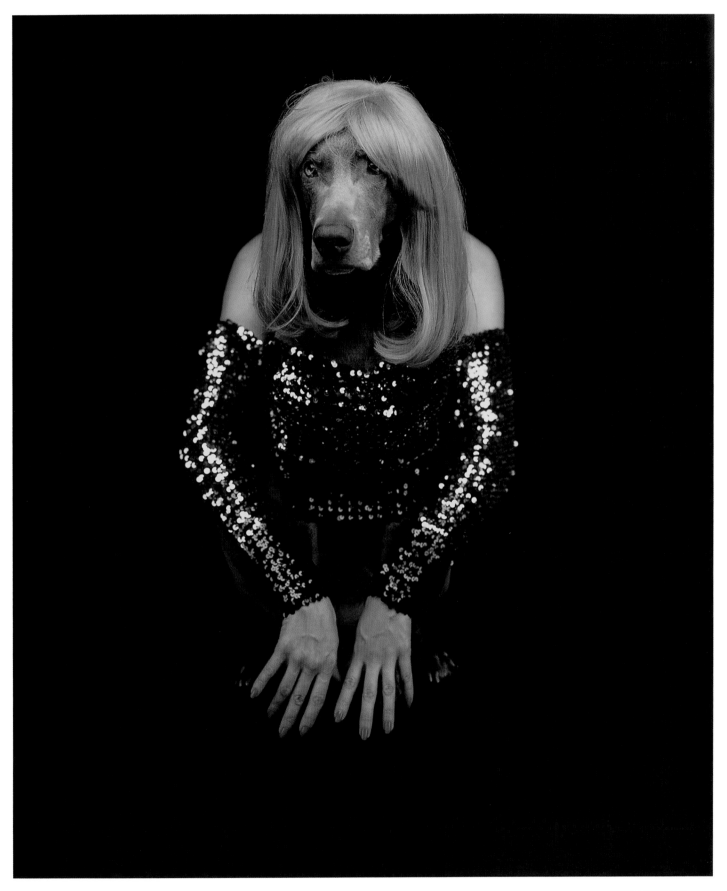

MISS MYTHICAL, 1994

OUTFIT, 1994

DESIGNERS

"Beach Scene"
1996
Dress
Moschino

"Ben Day" 1999
Hat
Kokin

"Bikini" 1999
Bikini
Dolce & Gabbana

"Blue Powder" 1994
Coat
Isaac Mizrahi

"Body Art" 1999
Shirt
Jean-Paul Gaultier

"Calla Lily" 1999
Hat
Bailey Tomlin

"Cockleshell" 1994
Skirt
Anna Sui

"Courrèges" 1994
Jacket
André Courrèges

"Cream Puff" 1999
Hat
Gabriela Ligenza

Cuffs
Kokin

"Daisy Legs" 1999
Skirt and halter top
Lilly Pulitzer

"Dessert" 1999
Dress
San Carlin

"Dressage" 1999
Dress
Jean-Paul Gaultier

"Duct" 1994
Skirt
Anna Sui

"Evolution of a
Bottle in Space" 1999
Skirt
Issey Miyake

"Eye of the Dog" 1999
Hat
Bailey Tomlin

"Feathered Foot" 1999
Shoes
Yves Saint Laurent

"Genghis Khan" 1999
Jacket
Creative Designs

Scarves (on feet)
Adrienne Landau

Red, black, and
brown boas
Adrienne Landau

Burgundy and
grape boas
Stella Cadente

"Gent" 1999
Hat
Guerra

"Glamour Puss" 1999
Glasses
Dolce & Gabbana

Chain
Andrea Jovine

"Glover" 1999
Gloves
Saks Fifth Avenue

"Guest" 1999
Tuxedo
Valentino

Cumberbund, tie,
and shoes
Saks Fifth Avenue

Tuxedo shirt
Giorgio Armani

"Hatter" 1999
Hats
Philip Treacy

"House of Miyake" 1999
Skirt
Issey Miyake

"In the Bauhaus" 1999
Tube top
John Bartlett

"In the Custody of
Pink and Blue" 1999
Dress
Dolce & Gabbana

"Lion King" 1999
Scarves
Adrienne Landau

"Little Red" 1999
Dress
Helmut Lang

"Melissa" 1994
Skirt and gloves
Anna Sui

"Midsummer's
Night Dream" 1999
Dress and jacket
Dolce & Gabbana

"Migratory" 1999
Hat
Miss Jones

"Minding the
Mannequin" 1999
Dress
*Victor Costa
by Nahdrée*

"Miss Mythical" 1994
Top
Anna Sui

"Nurse, Nurse" 1994
Dresses
Anna Sui

Hats
*James Coviello
for Anna Sui*

Handbags
*Erickson Beamon
for Anna Sui*

"Opening" 1999
Dress
Laundry

Gloves
Saks Fifth Avenue

Tuxedo
Valentino

Cumberbund, tie,
and shoes
Saks Fifth Avenue

Tuxedo shirt
Giorgio Armani

"Outfit" 1994
Skirt, top, and gloves
Anna Sui

"Outing" 1996
Umbrella, raincoat,
dress, and handbags
Moschino

"Pantyasaurus" 1999
Hosiery
Trenders

"Parfait" 1996
Dress
X-TASY

"Plebe" 1999
Gloves
Saks Fifth Avenue

"Pluto" 1999
Hat
Saks Fifth Avenue

"Polar Extreme" 1994
Coat
Todd Oldham

"Reader" 1999
Hat
Patricia Underwood

Glasses
Andrea Jovine

"Red Rig" 1999
Dress
Michael Morales

Gloves
Saks Fifth Avenue

"Red Weasel" 1994
Stole
*James Coviello
for Anna Sui*

"Ruffled Gesture" 1999
Shirt and pants
Gucci

"Scotty" 1999
Skirt
Alexander McQueen

"Sign Language" 1999
Gloves
Saks Fifth Avenue

"Sitter" 1996
Dress, jacket, shoes,
and scarves
Moschino

"Summer Cottage"
1999
Skirt
Issey Miyake

"The Bouncing Ball"
1996
Shirt and pants
Moschino

"This Way and That"
1996
Shirt and Pants
Moschino

"Torso or So" 1999
Shirt
Jean-Paul Gaultier

"Trainer" 1999
Dress
Jean-Paul Gaultier

"Victory" 1999
Skirt
Issey Miyake

"Walk-a-thon" 1999
Shoes
Dolce & Gabbana

"Windmill" 1999
Hat
Miss Jones

"Wrap" 1996
Suit, shirt, and shoes
Moschino

Textile (first page)
Gucci

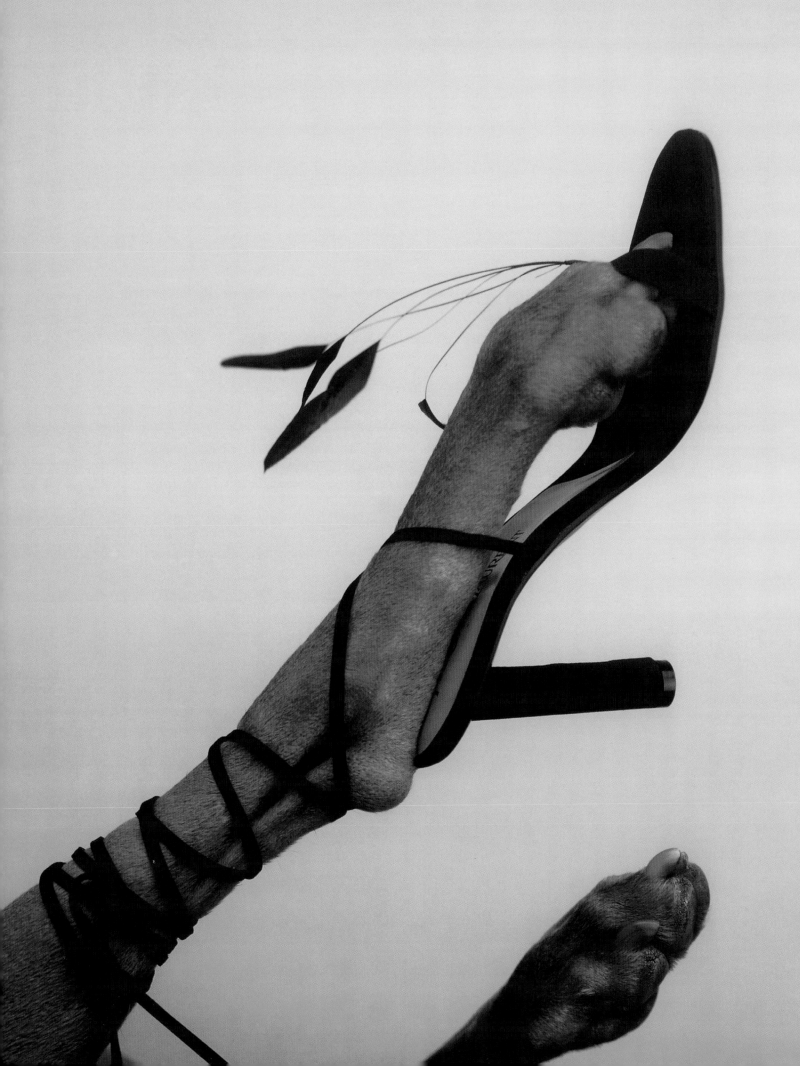

ACKNOWLEDGMENTS

With thanks to Saks Fifth Avenue and Saks Project Art
for all their help in making this project possible.

These photographs, this book, and the accompanying exhibition would
not have happened without the talents and monumental efforts of
Andrea Beeman; Jason Burch; Christine Burgin; Mary Dinaburg and
Dinaburg Arts LLC; Ben Fraser; Matt Gordon; Harry N. Abrams, Inc.,
Publishers; Tracey Hendel; Arnaldo Hernandez; Eric Himmel; Julie
Hindley; Morton Janklow of Janklow & Nesbit; John Koegel; Anne
Livet of Livet Reichard Company; Thomas Miller; David Moos,
Suzanne Stephens, and Gail A. Treschel of the Birmingham Museum
of Art; Daniel Morera; Heather Murray; PaceWildensteinMacGill;
Carmela Rea; John Reuter; Melanie St. James; Sarah Sockit;
Gary Tooth; Jennifer Traush; Veronica Webb; and Pam Wegman.

Models: Fay Ray, Battina, Chundo, Crooky, and Chip

All of the photographs in this book were taken with a
20 x 24" Polaroid camera

Editor: Eric Himmel
Design: Empire Design Studio

ISBN 978-1-4351-2944-3

Photographs copyright © 1999 William Wegman
Text by William Wegman copyright © 1999 William Wegman
Text by Ingrid Sischy copyright © 1999 Ingrid Sischy

Originally published in 1999 by Harry N. Abrams, Incorporated,
New York.

This edition published in 2010 for Barnes & Noble, Inc., by
arrangement with ABRAMS.

Printed and bound in China
10 9 8 7 6 5 4 3 2 1

THE ART OF BOOKS SINCE 1949
115 West 18th Street
New York, NY 10011
www.abramsbooks.com